YOUNG AMERICA

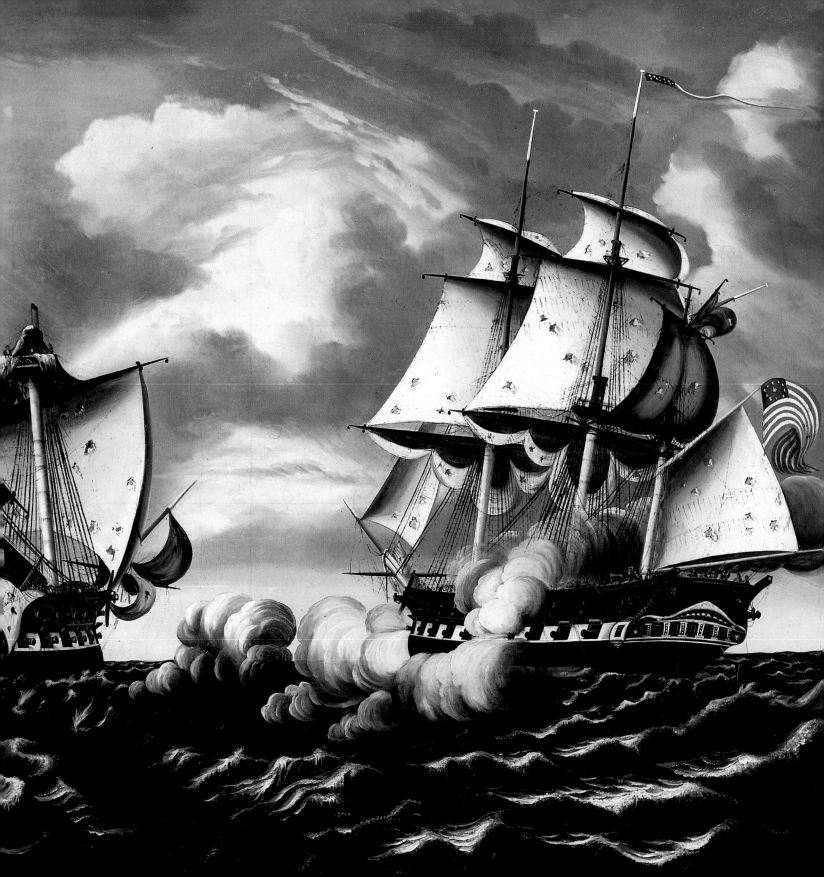

YOUNG AMERICA

Treasures from the
Smithsonian American Art Museum

Amy Pastan

Watson-Guptill Publications/New York

Smithsonian American Art Museum

Young America: Treasures from the
Smithsonian American Art Museum

By Amy Pastan

Chief, Publications: Theresa Slowik
Designers: Steve Bell, Robert Killian
Editor: Timothy Wardell
Editorial Assistant: Tami Levin

Library of Congress Cataloging-in-Publication Data

National Museum of American Art (U.S.)
 Young America : treasures from the Smithsonian
American Art Museum /
Amy Pastan.
 p. cm.
Includes index.
 ISBN 0-8230-0193-8
 1. Painting, American—Catalogs. 2. Painting—
Washington (D.C.)—Catalogs. 3. National Mu-
seum of American Art (U.S.)—Catalogs.
I. Pastan, Amy. II. Title.
 ND207.N3 1999
 759.13'074'73—dc21
 99-050579

Printed and bound in Italy

First printing, 2000
1 2 3 4 5 6 7 8 9 / 07 06 05 04 03 02 01 00

Cover: Raphaelle Peale, *Melons and Morning Glories*
(detail), 1813, oil. Smithsonian American Art Mu-
seum, Gift of Paul Mellon (see page 78).

Frontispiece: Thomas Chambers, *Capture of H.B.M.
Frigate* Macedonian *by U.S. Frigate* United States,
October 25, 1812 (detail), 1852, oil. Smithsonian
American Art Museum, Gift of Sheldon and
Caroline Keck in honor of Elizabeth Broun
(see page 20).

Young America is one of eight exhibitions in *Treasures to Go*, from the Smithsonian American Art Museum, touring the nation through 2002. The Principal Financial Group® is a proud partner in presenting these treasures to the American people.

Foreword

Museums satisfy a yearning felt by many people to enjoy the pleasure provided by great art. For Americans, the paintings and sculptures of our nation's artists hold additional appeal, for they tell us about our country and ourselves. Art can be a window to nature, history, philosophy, and imagination.

The collections of the Smithsonian American Art Museum, more than one hundred seventy years in the making, grew along with the country itself. The story of our country is encoded in the marvelous artworks we hold in trust for the American people.

Each year more than half a million people come to our home in the historic Old Patent Office Building in Washington, D.C., to see great masterpieces. I learned with mixed feelings that this neoclassical landmark was slated for renovations. Cheered at the thought of restoring our magnificent showcase, I felt quite a different emotion on realizing that this would require the museum to close for three years.

Our talented curators quickly saw a silver lining in the chance to share our greatest, rarely loaned treasures with museums nationwide. I wish to thank the dedicated staff who have worked so hard to make this dream possible. It is no small feat to schedule eight simultaneous exhibitions and manage safe travel for more than five hundred precious artworks for more than three years, as in this *Treasures to Go* tour. We are indebted to the dozens of museums around the nation, too many to name in this space, that are hosting the traveling exhibitions.

The Principal Financial Group® is immeasurably enhancing our endeavor through its support of a host of initiatives to increase national awareness of the *Treasures to Go* tour so more Americans than ever can enjoy their heritage.

Young America, the subject of this book written by Amy Pastan, is one of my particular favorites. Looking through the eyes of American artists, we witness the beginning of America's noble experiment and, following through the Civil War, we see it being tested and coming of age. Early portraits by John Singleton Copley, Gilbert Stuart, Charles Willson Peale, and Thomas Sully reveal values of people in New England and the mid-Atlantic. By the 1820s, landscapes by Thomas Cole, Thomas Birch, and Alvan Fisher tell of growing national ambitions, while an array of still lifes and genre paintings offer glimpses of more personal concerns.

Artists in the New World did not lose their connection with Europe. Elihu Vedder and Jasper Cropsey painted views of the Old World that remind us that many American artists kept one eye firmly on Europe. Many others referred to the classical roots of American democracy, as expressed in Horatio Greenough's and Hiram Powers's marble sculptures. And by the close of the Civil War, paintings by Samuel Colman and Homer Dodge Martin depict the transformation of the American landscape as a result of rapid industrial expansion.

The Smithsonian American Art Museum is planning for a brilliant future in the new century. Our galleries will be expanded so that more art than ever will be on view, and in an adjacent building, we are opening a new American Art Center—a unique resource for information on America's art and artists, staffed for public use. We are also planning new exhibitions, sponsoring research, and creating educational activities to celebrate American art and understand our country's story better.

Elizabeth Broun
Director
Smithsonian American Art Museum

WASHINGTON ALLSTON

1779–1843

Hermia and Helena

before 1818, oil
77.2 x 64.2 cm
Smithsonian
American Art
Museum

So close were the young Hermia and Helena—the two protagonists from Shakespeare's *Midsummer Night's Dream*—that the playwright declared them "two lovely berries moulded on one stem." Allston may have been thinking of this phrase when composing his luminous image of these companions, whose bodies visually merge as they share a book in the enchanted woods.

At a time when artists generally chose historical themes to express the character of a young nation, Allston looked instead to literary sources for inspiration, such as Shakespeare and the Romantic poets. A poet of some recognition himself, Allston was said to possess a rare philosophical and imaginative talent. Distinguished as a conversationalist whose "tongue wrought on his associates like an enchanter's spell," he used his imagination to convey spiritual and personal values. Hermia and Helena, seated together in a landscape of warm tones that highlight their intimacy, become the beautifully rendered symbols of tried but true friendship.

Museum purchase through the Smithsonian Institution Collections Acquisition Program and made possible by Ralph Cross Johnson, Catherine W. Myer, and the National Institute Gift

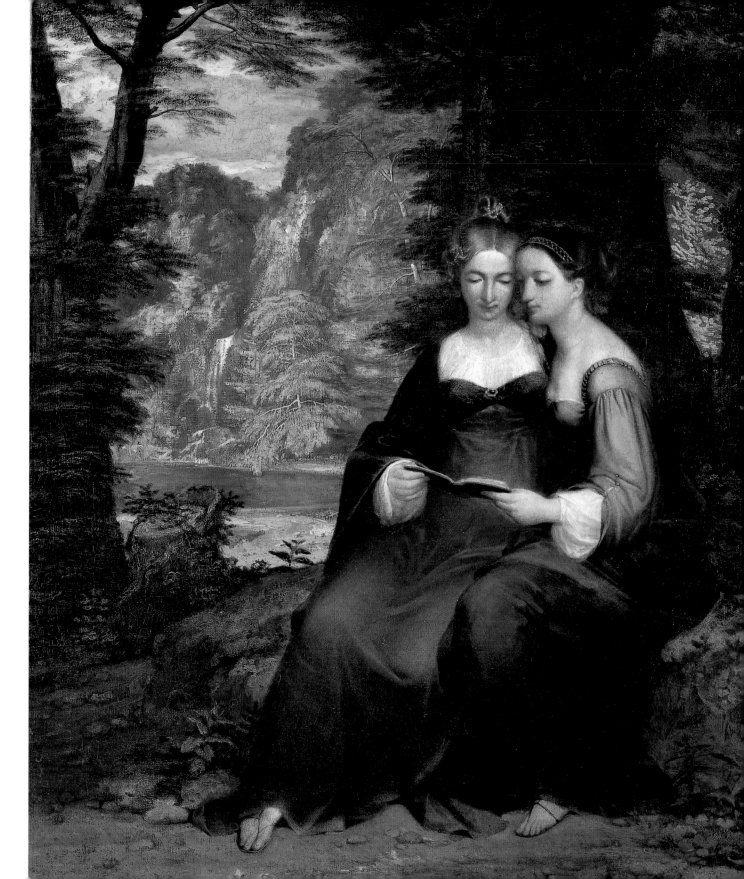

THOMAS BIRCH

1779–1851

Southeast View of "Sedgeley Park," the Country Seat of James Cowles Fisher, Esq.

about 1819, oil

87 x 122.9 cm

Smithsonian

American Art

Museum

A well-dressed family heads for a walk down the curving drive of a country home. The daughter stops to pick some berries. It is a spectacular day. The sun is just illuminating the house, which is a perfectly symmetrical structure with towers at each side connected by a portico. It differs from the other buildings in the distance, which are more typically American— a church with steeple, a farm shed in the middle ground, and a modified saltbox on the hill.

Thomas Birch depicts Sedgeley Park, the first American home in the Greek Revival style, which was designed by Benjamin Henry Latrobe, an architect of the U.S. Capitol. James Fisher, the estate's owner at the time Birch painted this canvas, was, as vice-president of a prominent bank, a solid Philadelphia success story. The ordered cultivation of the estate near the Schuylkill River close to Philadelphia conveys the prosperity of a young country confidently taming the natural landscape.

Museum purchase made possible by the Luisita L. and Franz H. Denghausen Endowment

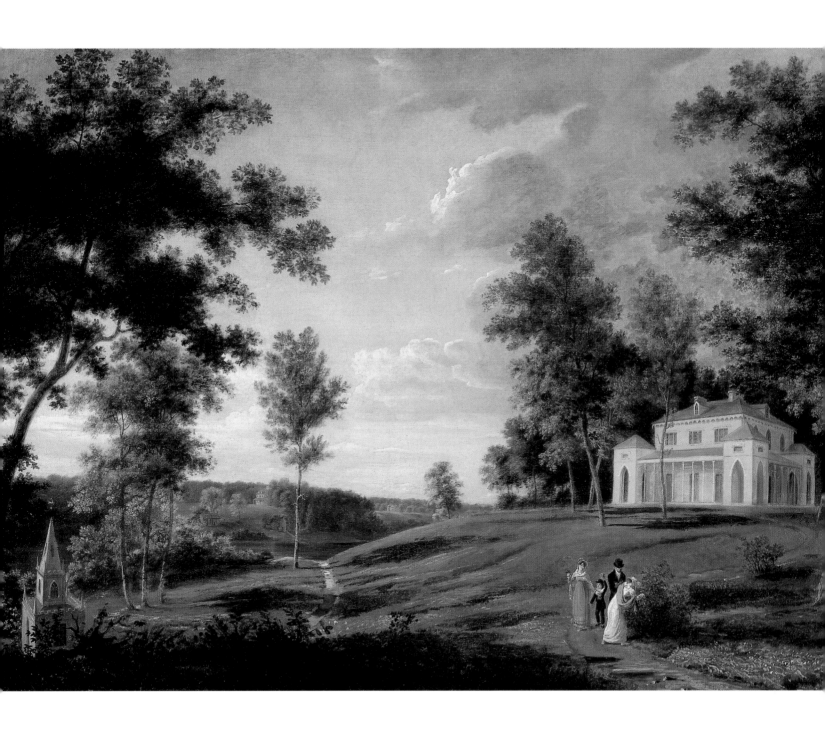

Boy Playing Marbles

about 1858, oil
55.6 x 67.4 cm
Smithsonian
American Art
Museum

This nineteenth-century "dead-end kid" possesses none of the charm associated with mischievous little boys. His squat disheveled form almost fills the canvas, but he seems uncomfortable, as if he can't accommodate his body in the orderly rectangular frame. His sly, almost calculating look, as he expertly flicks the marble, is as unnerving as his ragged appearance, which speaks to his neglect.

The artist David Gilmour Blythe—himself a dissolute and social misfit—painted several such street urchins whom he may have routinely noticed on the streets of Pittsburgh. All but forgotten for many years, Blythe is now recognized as an important satirist. His canvas makes us aware that decadence and destitution are age-old phenomena. Blythe's urchins, much like those in the popular novels of Charles Dickens, disgraced the society that had failed them. The boy playing marbles, crouched and conniving, emerges from the dark background as a symbol of society's ills.

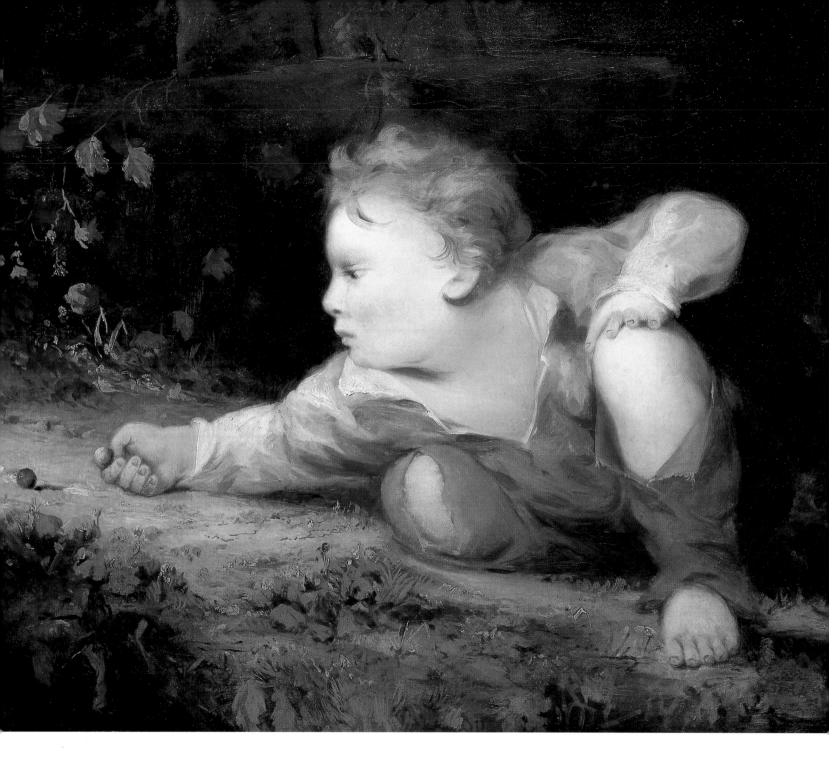

HENRY KIRKE BROWN

1814–1886

La Grazia

modeled about 1844
cast about 1850,
bronze
47.2 x 24.6 x 25.9 cm
Smithsonian
American Art
Museum, Gift of
Henry Kirke
Bush-Brown

With her headband and coiled hair, pupil-less eyes, and dignified bearing, "La Grazia" radiates the ideals of the classical world. The world of reason and measure is reflected in the perfect symmetry of her face, reinforced by her parted hair. The rich highlights of the warm-colored bronze give her a golden aura. Neoclassical sculptors at this time were using classical forms to refer to the democracies of ancient Greece, as well as to the concept of the human body as the ideal of beauty.

How ironic it is that this classical bust, which has the look of a goddess, is actually a portrait of the celebrated Maria Grazia, whose husband was a notorious bandit in nineteenth-century Italy. Imprisoned for her association with him, she forged a career posing for some of Rome's most prominent artists on her release from jail.

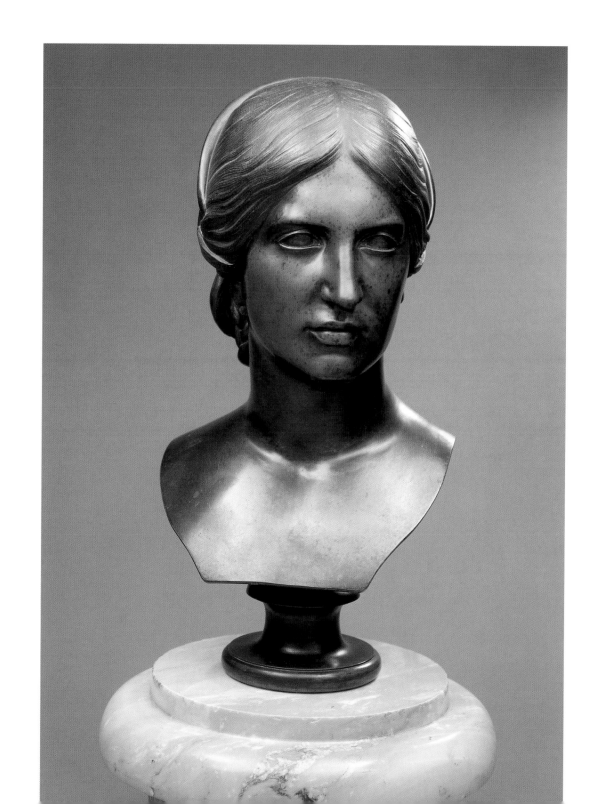

GEORGE CATLIN

1796–1872

Pigeon's Egg Head (The Light) Going to and Returning from Washington

1837–39, oil
73.6 x 60.9 cm
Smithsonian
American Art
Museum, Gift of
Mrs. Joseph
Harrison Jr.

This is a wonderful "before and after" portrait from a master painter of Native American cultures. In 1831, Pigeon's Egg Head (also known as The Light), an Assiniboine warrior, headed a delegation to Washington to meet with the president of the United States. Catlin, who had painted Pigeon's Egg Head in the splendor of his native costume, found him much changed after his visit to the capital. At left he heads toward Washington, with the White House faintly visible in the background. At right he returns to the teepees of his village, a certified dandy, with white gloves, top hat, cigarette, umbrella, fan, and liquor bottles protruding from his frock coat.

Sadly, after Pigeon's Egg Head "traveled the giddy maze" (as Catlin called it) of the white man's world, he was ostracized by his tribe. His people never believed the extraordinary tales of his travels. He was labeled a liar and eventually killed by his tribesmen, who considered him a traitor.

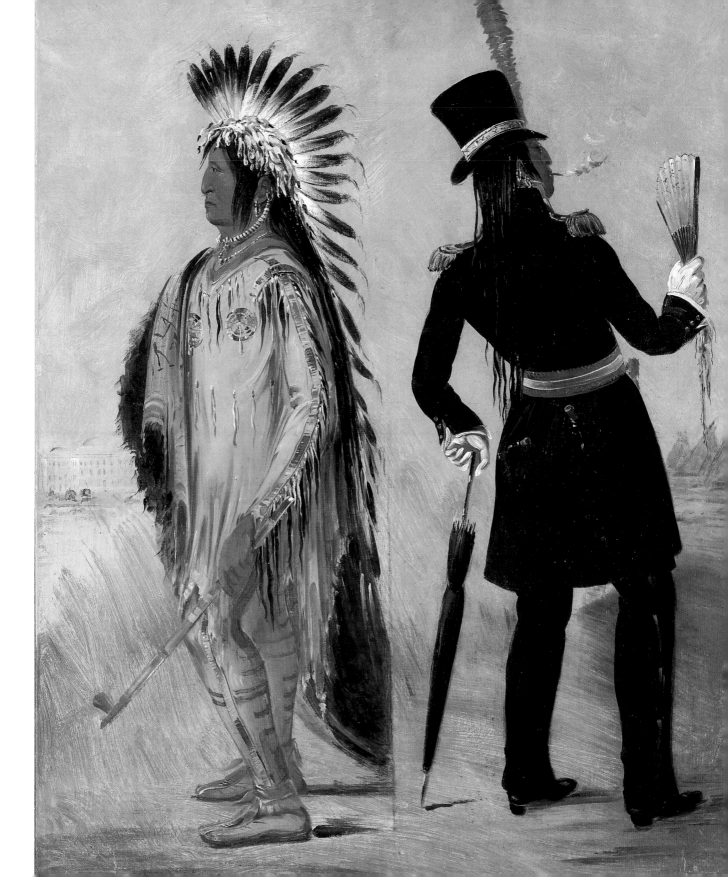

GEORGE CATLIN

1796–1872

No Horns on His Head, a Brave

Rabbit's Skin Leggings, a Brave

Catlin's wonderfully composed images of these Nez Perce braves were probably painted in St. Louis, when a Native American delegation passed through that city. Catlin had befriended General William Clark, of Lewis and Clark Expedition fame, in St. Louis. In addition to documenting his own extensive expeditions, Catlin sketched and painted Native Americans who visited Clark in his office. The dignified bearing of the young men and the attention to detail in the elaborately beaded tunics and beaded and feathered hair suggest that Catlin was impressed with his subjects. Native Americans, he wrote, were "the finest models in all Nature, unmasked and moving in all their grace and beauty."

The unfocussed gaze of these dignified braves rests at a point somewhere outside the canvas. Catlin's faithful effort to document the life of these peoples in the early nineteenth century captures those impressive cultures as they were before their world was shattered.

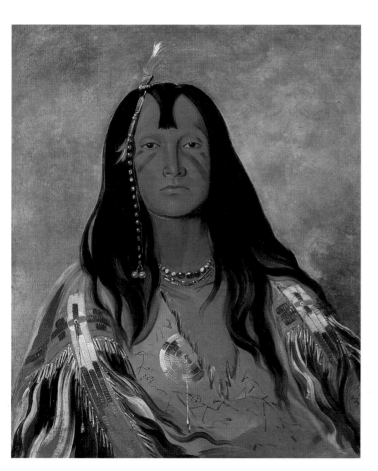

1832, oil, 73.7 x 60.9 cm

Smithsonian American Art Museum

Gift of Mrs. Joseph Harrison Jr.

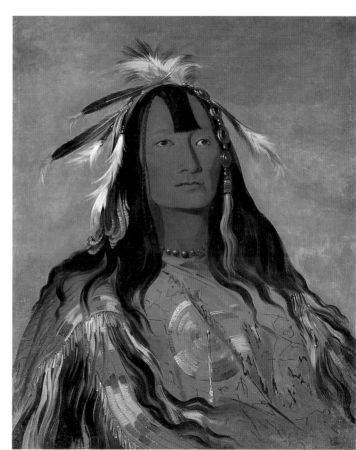

1832, oil, 73.7 x 60.9 cm

Smithsonian American Art Museum

Gift of Mrs. Joseph Harrison Jr.

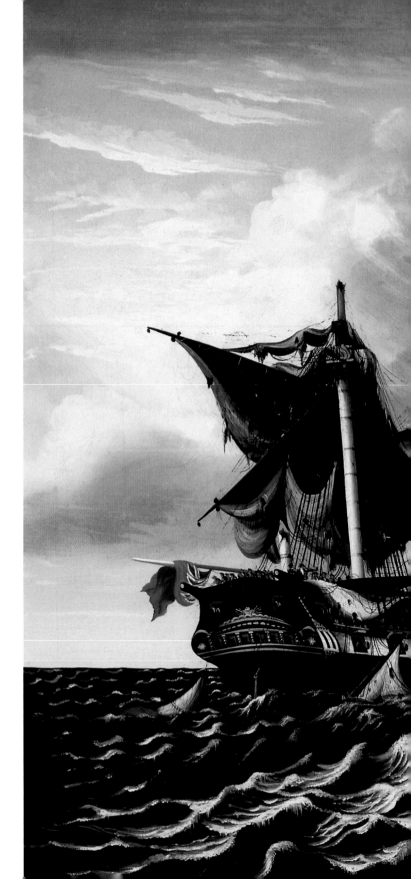

THOMAS CHAMBERS

1808–1879

Capture of H.B.M. Frigate Macedonian by U.S. Frigate United States, October 25, 1812

1852, oil
88.6 x 127.5 cm
Smithsonian American Art Museum, Gift of Sheldon and Caroline Keck in honor of Elizabeth Broun

The drama and motion of this image emphatically convey the noise and turmoil of a battle at sea. The painting commemorates an event during the War of 1812 in which Stephen Decatur commanded an American ship that captured a British frigate. The war, precipitated by U.S. insistence on neutral shipping rights, ushered in a period of great American nationalism and increased isolation from Europe. Based on earlier depictions of the skirmish, the scene has an immediacy—with the punctured sails, billowing smoke, and American flag whipping in the wind—that makes it a stirring statement of American patriotism.

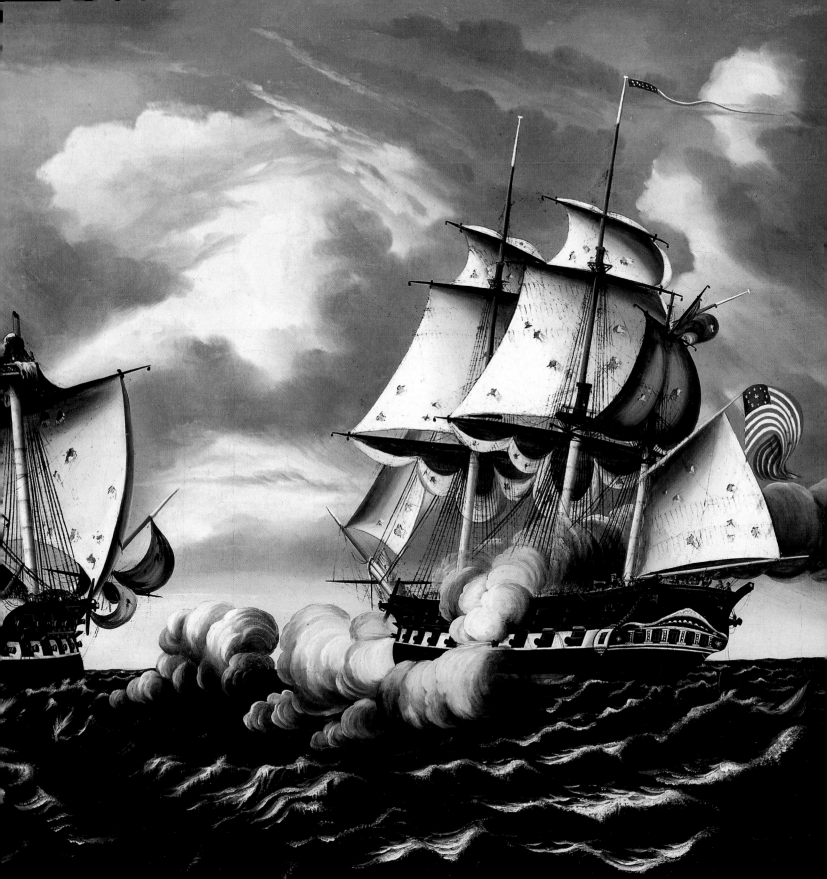

Aurora Borealis

1865, oil

142.3 x 212.2 cm

Smithsonian

American Art

Museum, Gift of

Eleanor Blodgett

The wildly electric sky in this grand canvas would seem more appropriate in the year 2000, but these northern lights were truly visible across the northern United States in late 1864. Contemporary accounts suggest that they were every bit as surreal as the ones Church depicts here. By uniting them with a desolate Arctic landscape, which the artist had also seen firsthand in 1859, he creates a breathtaking image, at once menacing and hopeful.

A trapped ship in an icy, oddly lunar landscape is both illuminated and diminished by an exhilarating display of natural fireworks. The spectacle fans out to the topmost edge of the picture plane and warms the frozen blue surface below with a fiery red reflection. Maybe the vermilion glow will thaw the impenetrable ice and liberate the ship—or at least light the way for the small team of dogs bringing aid to the immobilized vessel. A light glows from the ship's cabin. Despite the imposing glacier in the background and the heavenly pyrotechnics above, the crew appears safe for the night. For Frederic Church and his contemporaries, the northern lights were not just beacons of hope in a forsaken place. They also seemed an omen that the bloody battles of the Civil War would soon come to an end, with a victory for the Northerners, for whom they believed this celestial "message" was intended.

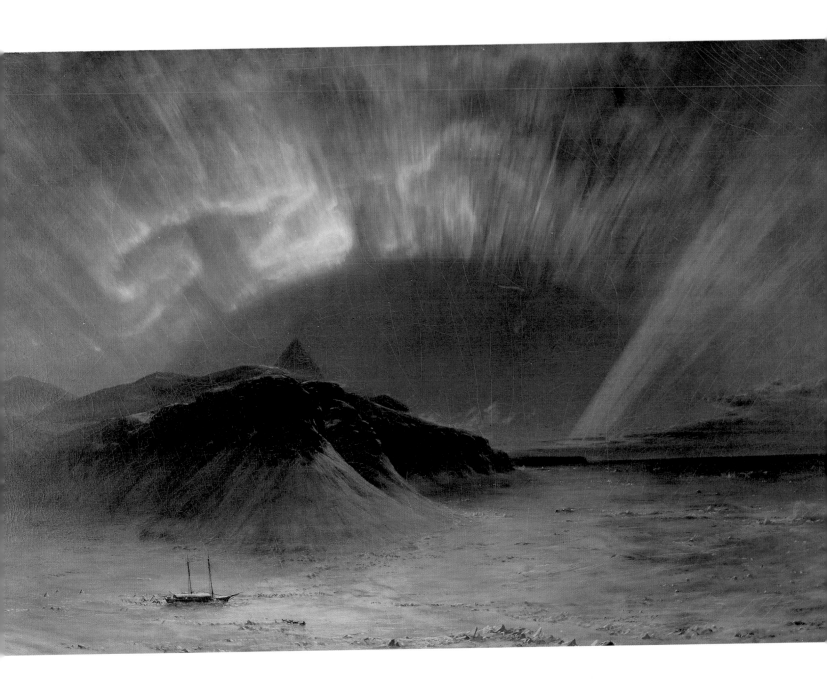

FREDERIC EDWIN CHURCH

1826–1900

Cotopaxi

1855, oil

142.3 x 212.2 cm

Smithsonian

American Art

Museum, Gift of

Mrs. Frank R. McCoy

Frederic Church was certainly well traveled! However, rather than visiting the usual tourist haunts he spent much of his career visiting the world's great unspoiled and exotic landscapes. The volcano Cotopaxi, which Church first saw in 1853, rises above the Ecuadorian countryside. He painted many different versions of this landmark. Its white cone reveals how perfect nature can be and how it dominates the world of man—represented here by the hacienda, to which a farmer and his burros make their way.

Church's pictures were rarely judged on their artistic merits alone. They were documents of scientific investigation. He was strongly influenced by the writings of the German naturalist Alexander von Humboldt, whose publication of his own exploration of South America alerted the world to the wonders of the American tropics. South America represented to mid-nineteenth-century America a vision of the world as it appeared at the very beginning of time. This powerful portrait of a natural phenomenon reveals the dawn of a new era in the scientific quest to explain the physical world and its origins.

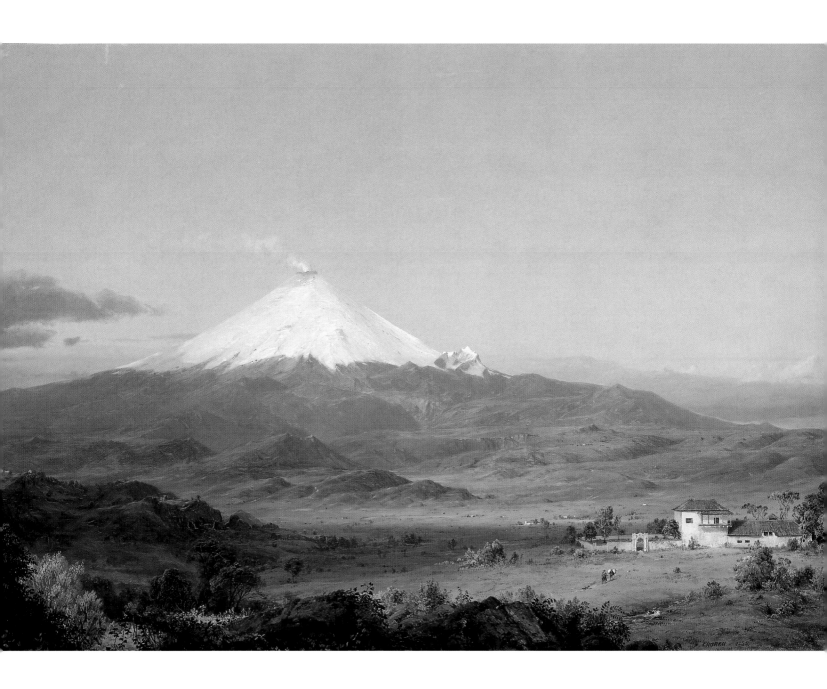

THOMAS COLE

1801–1848

The Subsiding of the Waters of the Deluge

1829, oil
90.8 x 121.4 cm
Smithsonian
American Art
Museum

We are viewing the aftermath of terrible violence. Tree limbs, debris, and a small skull at the bottom of the canvas are reminders of the ordeal. And while there are no survivors in the picture, the artist, by extending the perimeter of the rocky enclosure around the picture's edge, has given us that fictive role, as though we are gazing at the scene from within a rugged cave. Spray from the falls at upper left fills the natural graveyard in which we find ourselves. But the worst is over. We see the calm water and looming peak on the horizon. An extraordinary glow illuminates the small ark on the waters, a symbol of renewed life.

For Thomas Cole, this story of the Biblical flood was a veiled reference to his adopted country, the United States. Washed clean of the corruptions of European monarchy, the new democracy awakens to a promising future.

Gift of Mrs. Katie Dean in memory of Minnibel S. and James Wallace Dean and museum purchase through the Smithsonian Institution Collections Acquisition Program

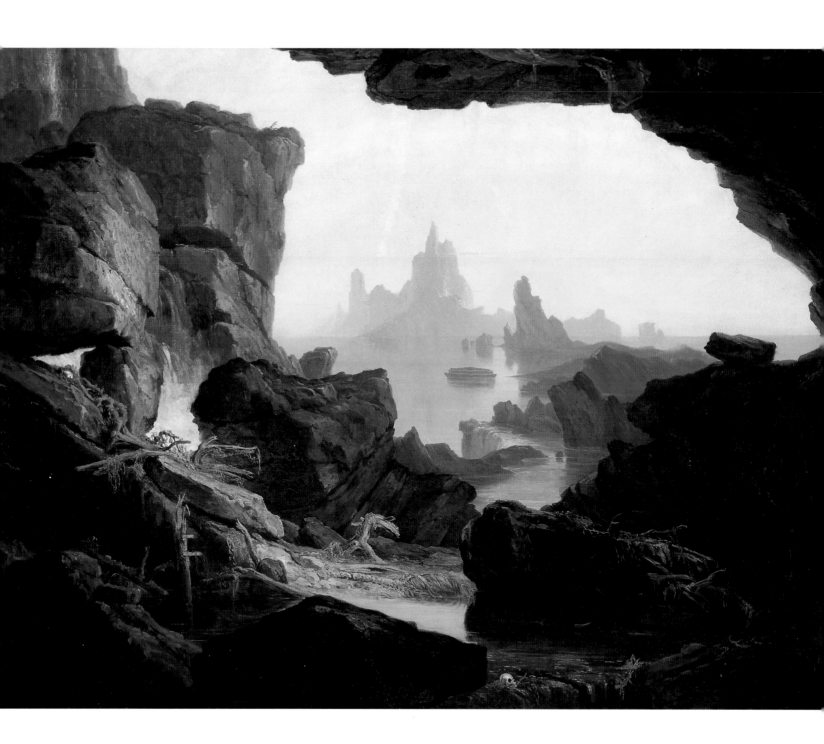

SAMUEL COLMAN

1832–1920

***Storm King
on the Hudson***

1866, oil
81.6 x 152 cm
Smithsonian
American Art
Museum, Gift of
John Gellatly

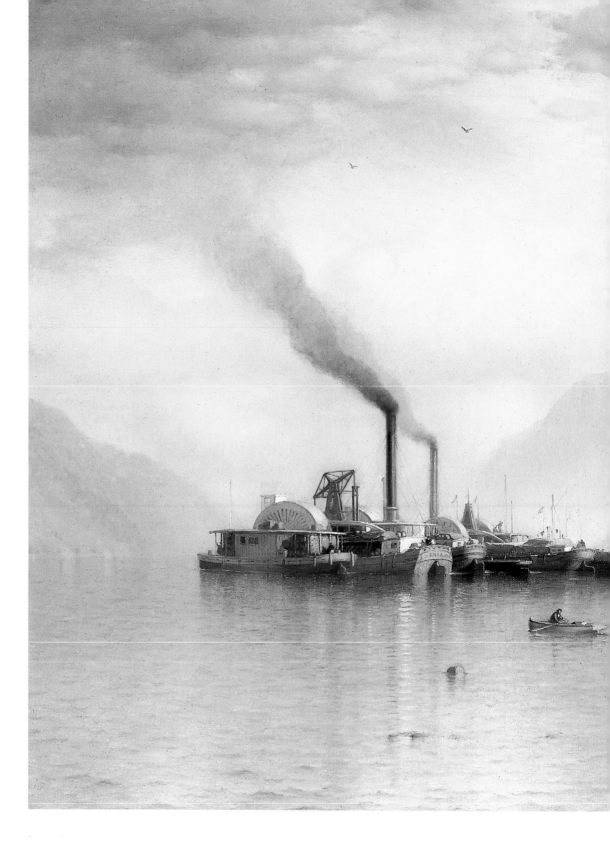

S.COLMAN_ 66.

JOHN SINGLETON COPLEY

1738–1815

Mrs. George Watson

1765, oil

126.7 x 101.6 cm

Smithsonian

American Art

Museum

Even before focusing on her strong face, you are swept up in Mrs. Watson's crimson dress. It is dazzling, with sweeping strokes to show off its perfect fit across her slender torso. The left sleeve, highlighted with thick bands of pink, reveals just how lavish this satiny fabric is. Pearl clips fasten the heavy rich material above the dainty lace trim. The white satin drapery sends a shimmering horizontal line across the canvas, leading from Mrs. Watson's right hand to the table, where she clasps a valuable Delft vase, which holds an imported, and equally costly, tulip.

The sitter, Elizabeth Oliver Watson, was a cousin of Copley's wife, daughter of a Boston judge, and wife of a prominent Tory merchant. Late-eighteenth-century Boston was a vital center of shipping and trade in America and Copley's clientele appreciated the fact that he included in their portraits examples of the quality merchandise that they so prized.

Partial gift of Henderson Inches Jr. in honor of his parents, Mr. and Mrs. Inches, and museum purchase made possible in part by Mr. and Mrs. R. Crosby Kemper through the Crosby Kemper Foundation; the American Art Forum; and the Luisita L. and Franz H. Denghausen Endowment

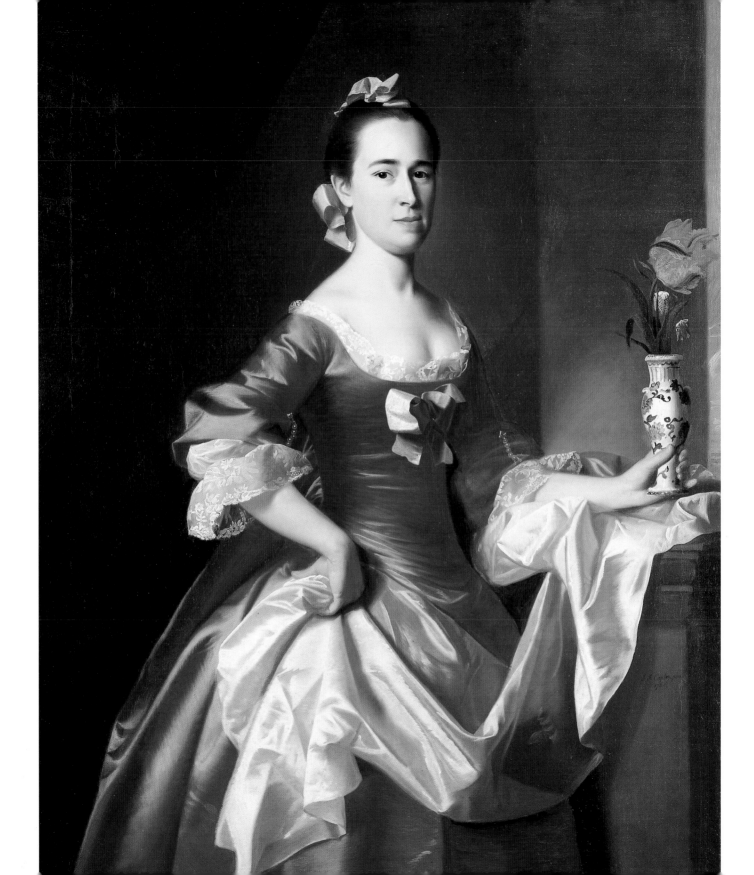

JASPER FRANCIS CROPSEY

1823–1900

The Coast of Genoa

1854, oil

122.4 x 184.2 cm

Smithsonian

American Art

Museum, Gift of

Aileen B. Train,

Helen B. Spaulding,

and Julia B. Key

If you plant your feet on the floor and stand directly in front of this large canvas, you will feel as if you are moving. The artist has divided the picture into so many levels—swelling waves against the rocky pier in the foreground, the listing boat before the cliffs leading up to the town, and a multi-tiered tower looming toward the jagged snow-capped peaks—that you actually feel queasy. Still, the very turbulence of the scene is invigorating. As the puffy clouds thin out over the mountain and then gather ominously at left, you imagine the wind that whips up the water, and you get a sense of what it would have been like to be at the port of Genoa in the 1850s.

In addition to the drama of nature depicted so splendidly by Cropsey—the upward brush strokes of his blue-green waves seem to swell out of the picture frame—another form of pageantry is enacted in town, where a miniscule regiment of soldiers in full regalia parades across the bridge.

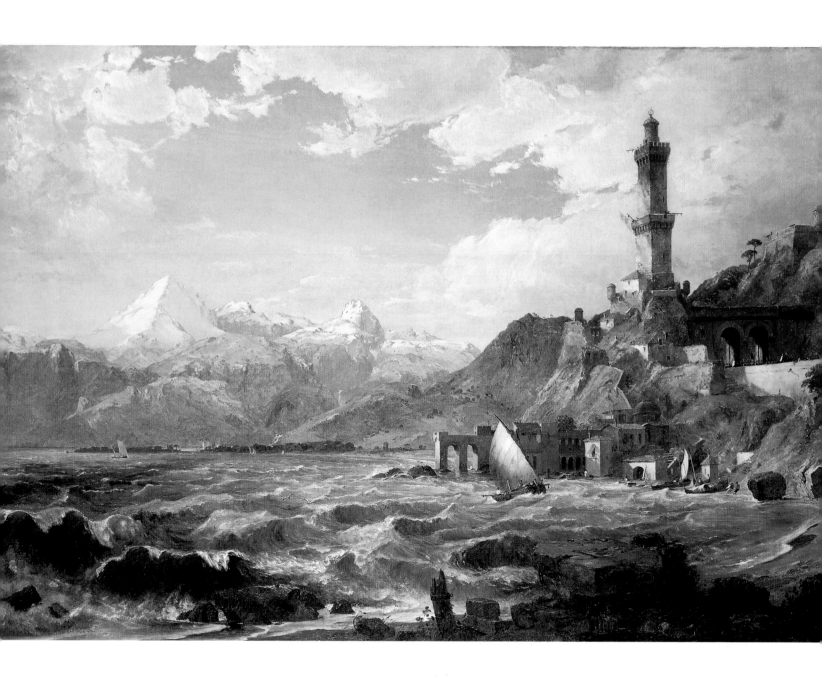

ROBERT SCOTT DUNCANSON

1821/22–1872

Landscape with Rainbow

1859, oil
76.3 x 132.7 cm
Smithsonian
American Art
Museum, Gift of
Leonard and
Paula Granoff

Duncanson used the Ohio countryside of his youth as the setting for this idealized landscape, which shows the artist's skillful use of color and light. In horizontal bands from the fertile foreground to the pristine lake, golden hills, benign clouds, and prism arching into the atmosphere, we ascend an imaginary ladder of perfection, where the world is calm, reassuring, orderly, and exhilarating.

Duncanson, whose parents were of African descent, rose from house painter to become the first African American artist to gain an international reputation. He painted this landscape as the nation moved steadily toward the Civil War. He may have been looking forward in this idyllic scene to the day when all Americans would gain equality. The two small figures, who stride arm in arm through the Eden-like composition, seem to have found the promised land. The rainbow is their bridge to a future where the kind of prejudice Duncanson struggled against would be eradicated.

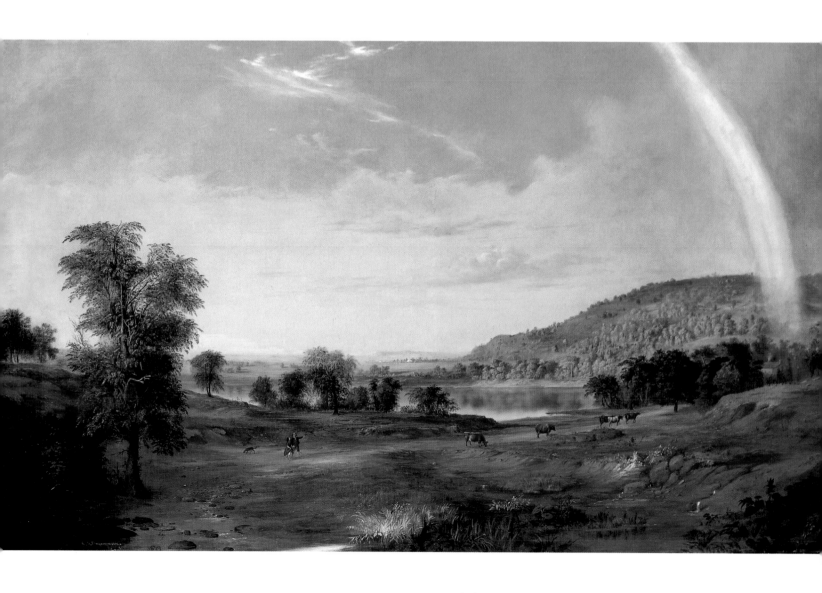

ASHER B. DURAND

1796–1886

Dover Plain, Dutchess County, New York

1848, oil

107.9 x 153.7 cm

Smithsonian

American Art

Museum,

Gift of

Thomas M. Evans

This idyllic view of a boy and two girls picking berries conveys peace and well-being. These simple pleasures on a sunlit day suggest a contentment that cannot be disturbed. Even the mountains—gentle, green, and softened by a faint haze—are completely reassuring. While the boy at left creeps down a rock to retrieve berries for his young companion with the basket, a third child, in a red dress with a blue bonnet, turns her back to the viewer and shields her eyes. Is the glare of the sun hampering her view or is she attempting to look far across the long horizon to the possibilities that exist for America's future?

Durand, a stickler for detail, has gotten everything right, from the native species of trees and plants to the harmony among the people, grazing cattle, and hills. The years he spent painstakingly sketching the landscape of upstate New York in order to re-create this scene in his studio are not immediately apparent in this seemingly effortless depiction of the coexistence of man and nature.

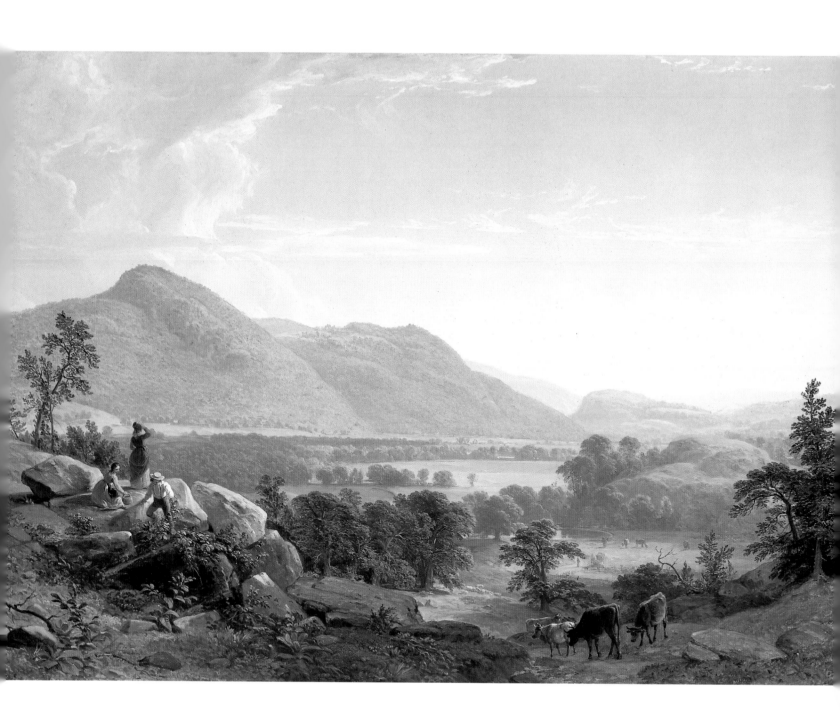

Winter Scene in New Haven, Connecticut

about 1858, oil
45.6 x 60.9 cm
Smithsonian
American Art
Museum

A storm seems to be gathering in the distance, yet there is a sense of calm in the orderly house and yard, where a family goes about its daily routine. Most everything we see in this domestic scene is man-made. There is not one irregular slat in the tidy fences. A fresh snowfall has left its trace on the scene, with tiny strokes of white clinging to the trees. The smoke spiraling up from the chimney of the red house reinforces the notion of warmth and well-being. Only the dogs seem giddy, stirred by the animals' sense of what nature has in store.

This canvas evokes nostalgia for a time in New England's past that is hard to reclaim. Even when Durrie painted this scene, the simple life was fading. After the Civil War, it was irretrievable. Such yearning fueled the popularity of prints by Currier and Ives, several of which reproduced Durrie's comforting images.

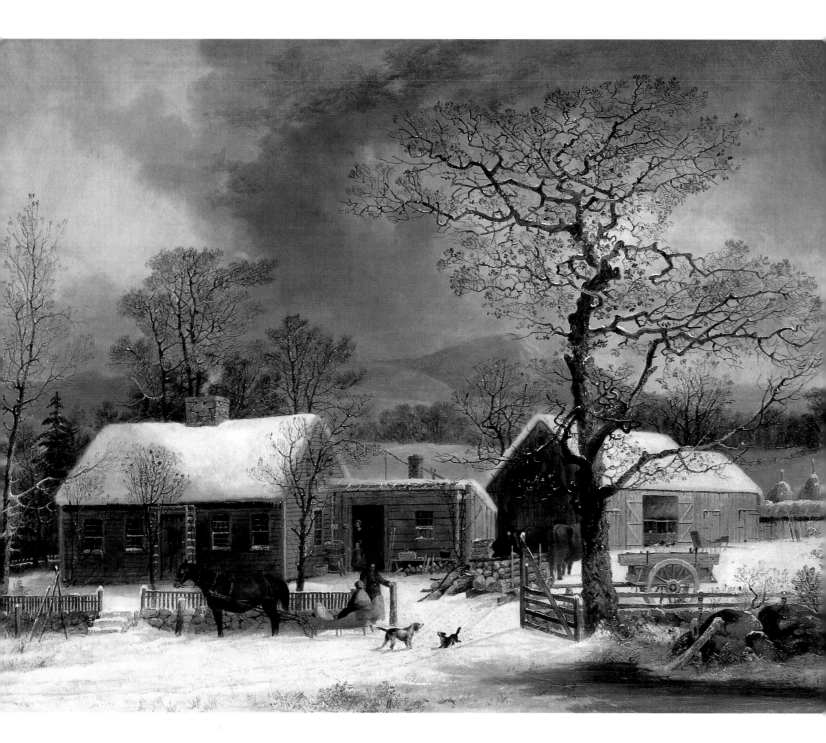

RALPH EARL

1751–1801

Mrs. Richard Alsop

1792, oil
115.8 x 61.7 cm
Smithsonian
American Art
Museum

The imposing Mrs. Alsop sports an impressive bonnet, which heightens her stately and upright posture. Grasping a small gilt box in one hand, and holding a handkerchief in the lap of her broadly draped dress, she is a woman in control of her life. A subtle pull of her mouth to one side suggests a bit of humor in her otherwise severe expression.

The artist has taken extraordinary care with the details of Mrs. Alsop's green satin dress. Bold strokes of paint suggest the sumptuous folds, while more delicate touches are used for the homey lace draped about her. As if to preserve her erect dignity, Mrs. Alsop appears completely oblivious to the meandering and inviting landscape behind her. Although the landscape depicts the river near her Connecticut farm, she seems more attached to her rich red chair and the gold-fringed curtain draped behind her, which better convey her status in colonial New England society.

Museum purchase and Gift of Joseph Alsop

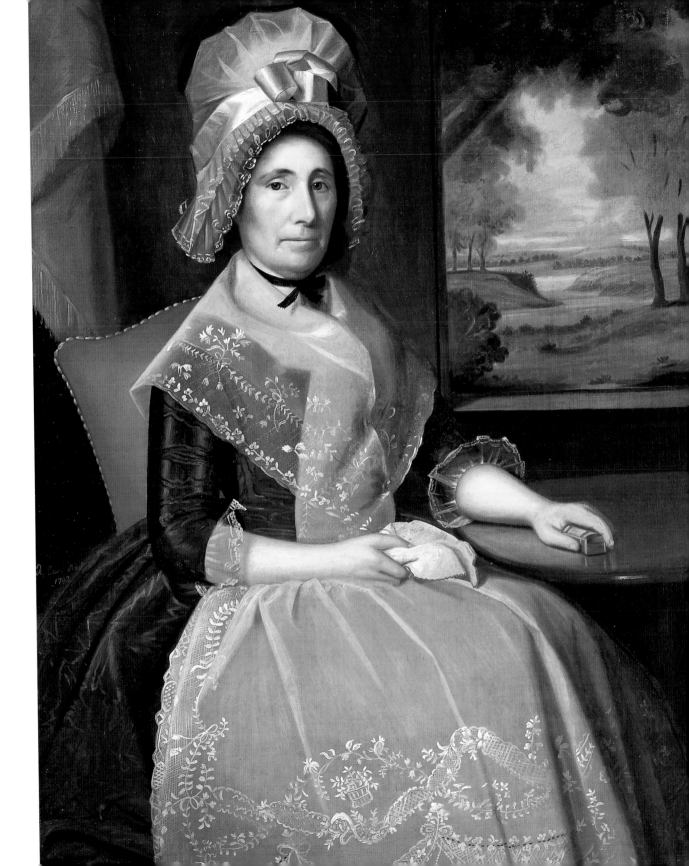

FRANCIS WILLIAM EDMONDS

1806–1863

The Speculator

(detail)

1852, oil

63.7 x 76.4 cm

Smithsonian

American Art

Museum

Marketing tactics haven't changed much since 1852. In the modest home of a hardworking couple sits an overdressed representative of the Building Association (identified by a paper protruding from his coat pocket). His top hat and umbrella—so out of place here—have been set aside so he can unroll his plans for "1000 Valuable Lots on Rail Road Ave!" to show his skeptical but interested audience. His black pointed shoes stand out conspicuously on the simple wooden floor.

Can this salesman really free them from their arduous life, or are his promises as hollow as the interior of the top hat? Edmonds certainly knew the type he painted. He spent more than a year observing rural life around the upper Hudson River before embarking on a career in banking in New York City. In his travels, he probably encountered such land speculators preying on simple people, a common sight. Still, the work is more funny than it is serious. After all, the husband—who is giving his attention to his basket of corn—seems to exhibit greater faith in his own abilities and hard work than in the dandy with dreams on paper.

Gift of Ruth C. and Kevin McCann in affectionate memory of Dwight David Eisenhower, 34th President of the United States

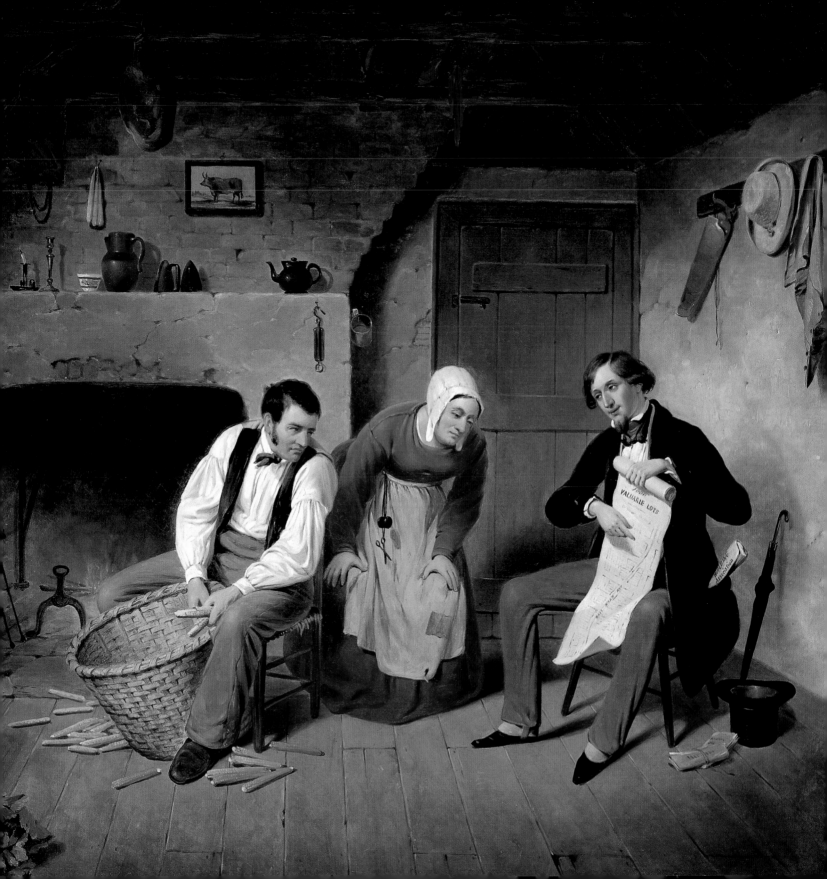

JOHN WHETTEN EHNINGER

1827–1889

October

1867, oil
82 x 137.6 cm
Smithsonian
American Art
Museum

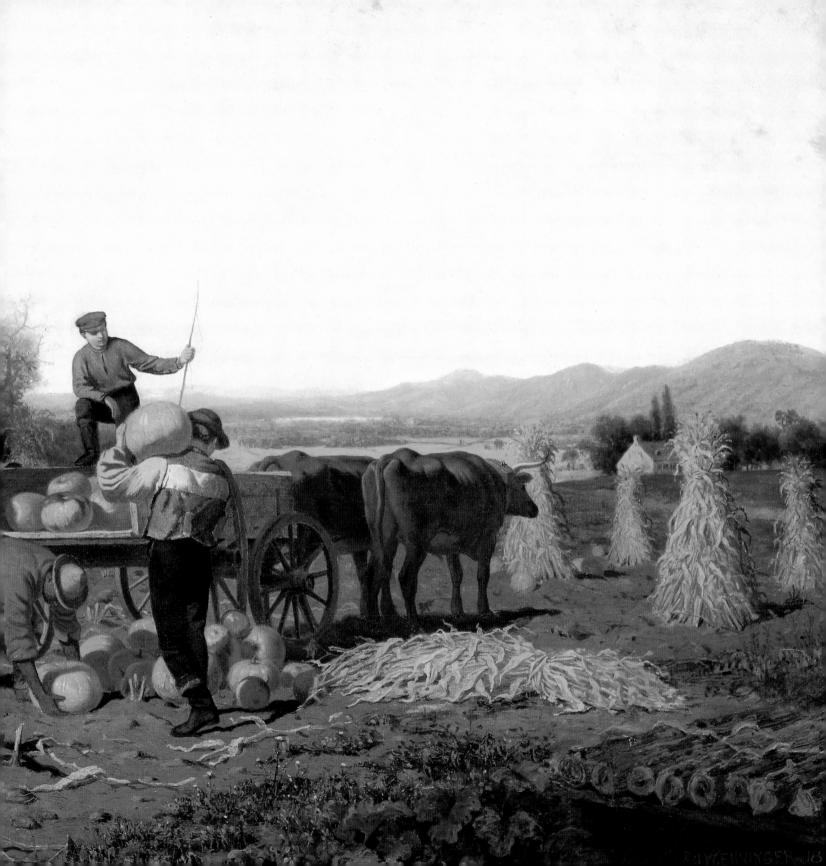

ALVAN FISHER

1792–1863

The Great Horseshoe Fall, Niagara

1820, oil

87.2 x 122 cm

Smithsonian

American Art

Museum

What is that deafening roar? Even if you've never heard it, you can sense the thunderous reverberation of crashing water in this image of Niagara Falls. At first you notice the magnificent pink sky giving way to blue after a rainstorm, which has also left the most perfect rainbow arching into the churning foam. But then you realize the commotion in the foreground. Three figures are much too close to the precipice above the water, and all of them, their small bodies straining into the spray, are reaching for a runaway hat that is about to fly over the edge. A spotted dog clings to the rocky ledge with shaky legs. Will he come to his senses and move away from danger?

Only a group of well-dressed tourists has the common sense to stand back. While a man, perhaps their guide, explains the natural spectacle before them, one of the women crouches with her hands over her ears. Surely the sound of the great Falls is overwhelming, but she also appears to be bowing in reverence to the powerful and awe-inspiring scene before her. The eroded cliffs to the right of the painting are evidence of the destructive power of the water.

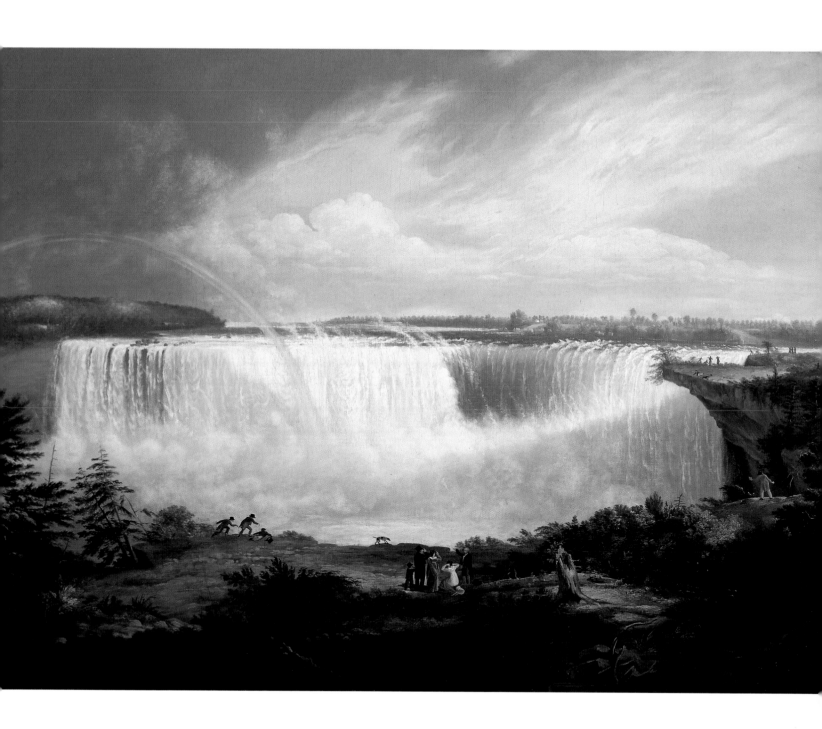

ALVAN FISHER

1792–1863

*A General View
of the Falls of
Niagara*

1820, oil
87.2 x 122.3 cm
Smithsonian
American Art
Museum

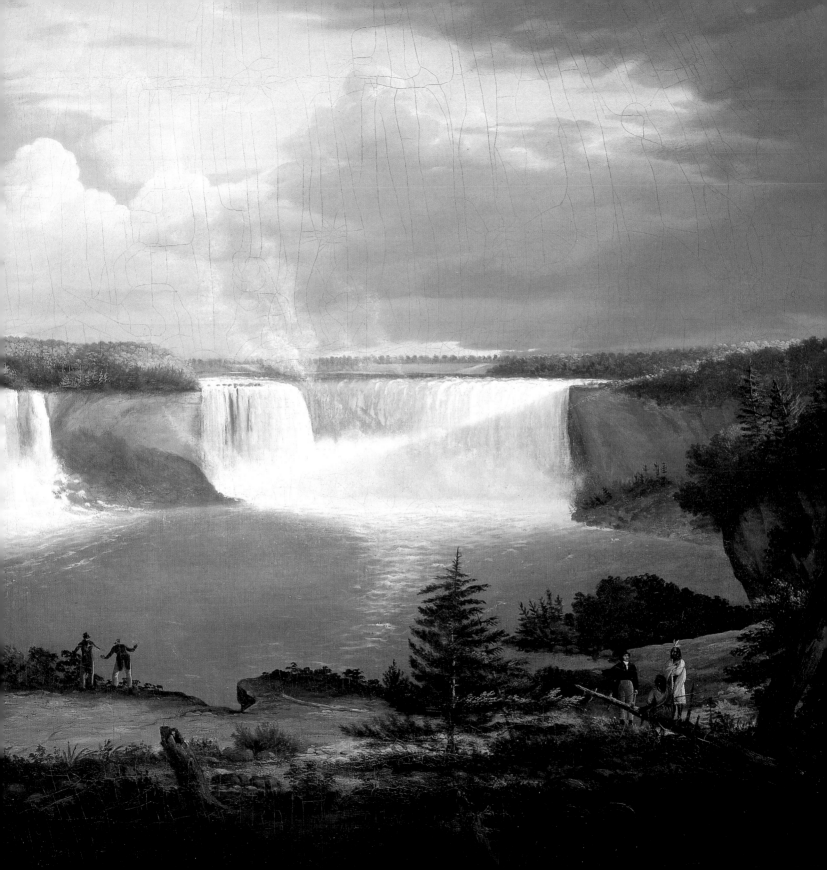

JOHN F. FRANCIS

1808–1886

Luncheon Still Life

about 1860, oil
64.6 x 77.2 cm
Smithsonian
American Art
Museum

The monumental architecture and extensive landscape in the background make this an unusual treatment of the still-life motif. Grapes have already been plucked from their stems and some of the nuts are cracked. Still, there is a haunting beauty to it all that we can't help but admire. The artist has so painstakingly rendered the fine crystal of the glasses, the diaphanous tablecloth, and the intricate porcelain pitcher that we are tempted to touch them. The composition, with items descending in size from the top of the basket to the table edge, is mesmerizing. But it is late, and the food will not last forever. At least this seems to be the suggestion of Francis's still life, which hints at the temporal quality of living things.

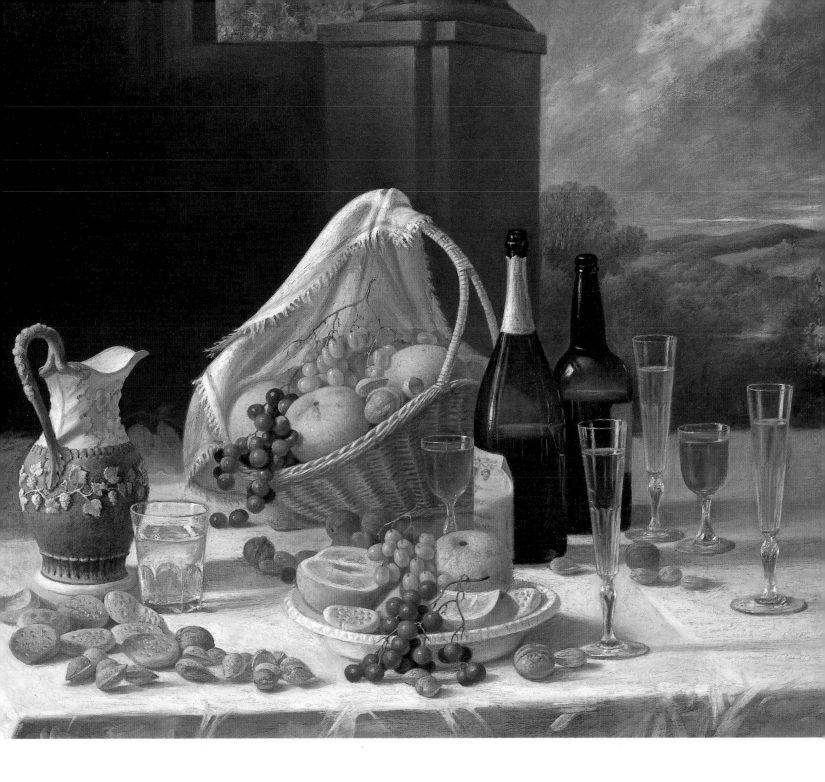

SANFORD ROBINSON GIFFORD

1823–1880

Whiteface Mountain from Lake Placid

1866, oil

29.5 x 49.8 cm

Smithsonian

American Art

Museum, Gift of

Mrs. Johnson Garrett

In 1846 Gifford made a sketching tour of the mountains of upstate New York that forever fixed his interest in landscape painting. From that time on Gifford was in love with the Adirondacks, so much so that he made his paintings of that area, such as this of Whiteface Mountain, into shrines to the unspoiled landscape. This pristine image of the mountain, which rises majestically above its own reflection in the lake's clear waters, appears to cast a hypnotic hold on daily activities, including the languidly drifting rowboat in the center of the canvas.

Changes in nineteenth-century life were quickly encroaching on the American wilderness, and there was growing concern from conservation groups—to which Gifford belonged—that such beauty must be preserved. Gifford used his artistic skill to aid in these efforts. Although he may have also utilized his talented brush to eliminate unattractive features of contemporary life from his luminous landscapes, it is our good fortune to see such scenes as this through his eyes.

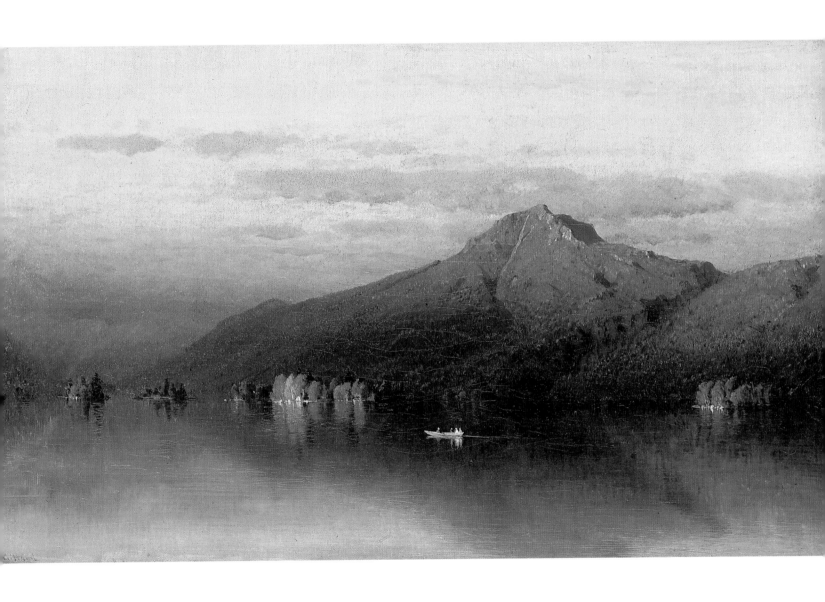

SANFORD ROBINSON GIFFORD

1823–1880

Villa Malta, Rome

1879, oil
33.6 x 69.5 cm
Smithsonian
American Art
Museum, Gift of
William T. Evans

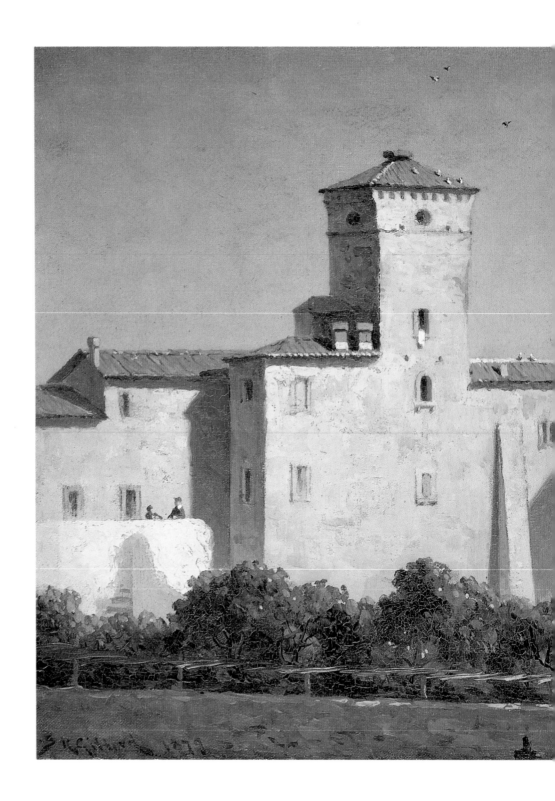

HORATIO GREENOUGH

1805–1852

Samuel F. B. Morse

1831, marble
49.5 x 30.5 x 22.2 cm
Smithsonian
American Art
Museum, Gift of
Edward L. Morse

Early in his career Horatio Greenough sought an introduction to the arts community from Samuel Morse, an artist and inventor, who was also founder of the National Academy of Design. Later, while living in Italy in the 1830s, Greenough was able to repay the favor by hosting Morse along with a prominent group of expatriate artists at his studio in Rome. The two became intimate friends and used each other as models. This classical bust of Morse was made at that time. Morse, looking more like a Greek god than a New England painter, represents an artistic ideal rather than an accurate expression of humanity.

Years later Morse's status in life was elevated almost to godly proportions through his involvement with the sciences. His interest in an electro-magnetic system of transmission led him to develop what we now refer to as "Morse code." He sent the first successful telegraphic message from Washington to Baltimore in 1844.

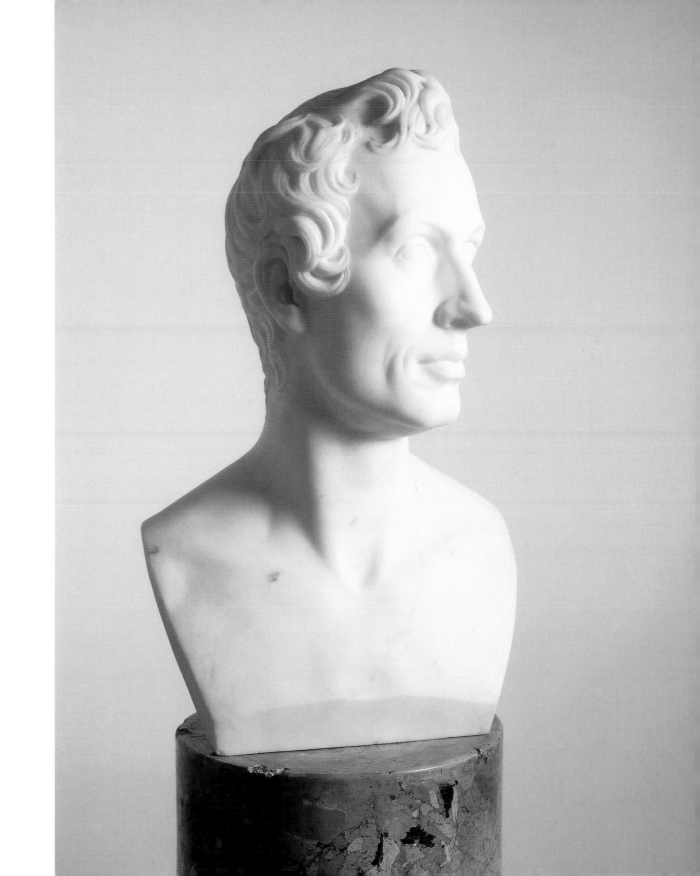

JOHN VALENTINE HAIDT

1700–1780

Young Moravian Girl

about 1755–60, oil
77.2 x 64.2 cm
Smithsonian
American Art
Museum, Gift of
the American
Art Forum

This portrait of a young Moravian girl may speak to the straightforward ways of this Christian group that came to Pennsylvania to reestablish its church. The Moravian denomination strictly adhered to the biblical scriptures as a guide to behavior and decorum. The girl's traditional costume relates to the group's German/Bohemian origins. The charming red bow, flushed cheeks, and bright eyes of the young subject hint at a more animated personality than the erect posture and proper dress imply. Her hands, too, one pointing up and the other down, lend a grace to the image.

In addition to being a painter, Haidt was a lay preacher in the Moravian community. This work not only documents the simple culture from which he came, but reminds us that the search for religious freedom that led our forefathers to this country was still a unique and wholly American concept in the eighteenth century.

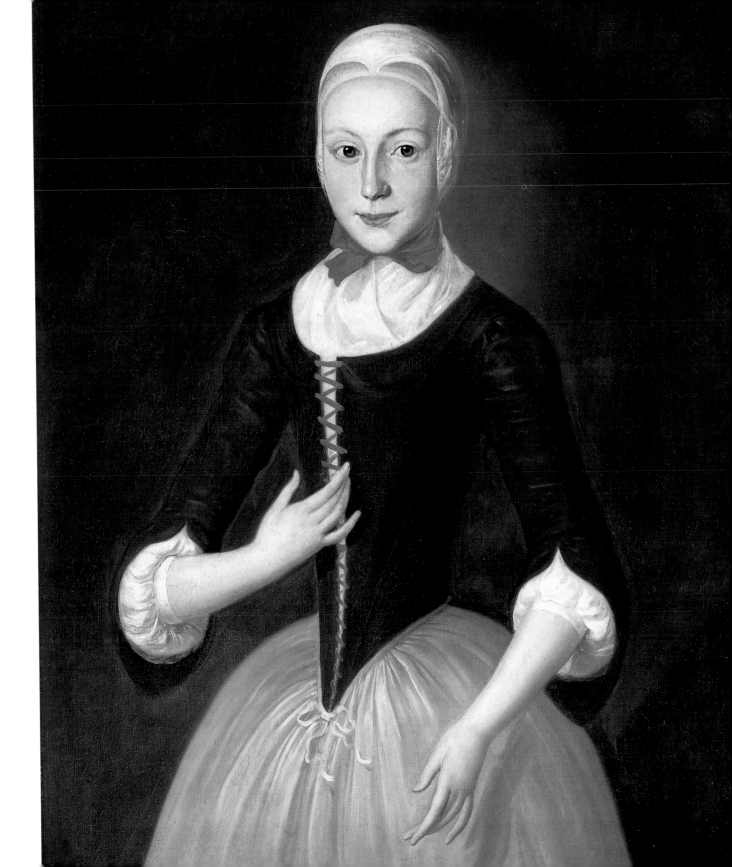

HARRIET HOSMER

1830–1908

Puck

Will o' the Wisp

Who is this petulant cherub Puck, poised to hurl a giant beetle with one hand while pinning a lizard, whose tail curls seductively up his arm, in the other? This must be nature's bad boy. From his marble toadstool—a fitting throne for a renegade angel—he plays at being king of the woods. A scallop shell serves as his crown. With unruly ringlets dangling down to his eyes he dares us to come closer where he will unleash his natural weapons. Fortunately, he is just a nineteenth-century child, perhaps reminding the sculptor's wealthy patrons of their lost youth. And they loved him! Hosmer sold more than fifty replicas of this impish character from Shakespeare's *Midsummer Night's Dream,* including one to the Prince of Wales, making her one of the most commercially successful women artists of her time. In a companion piece done several years later she sculpted the mischievous fairy Will o' the Wisp from the same Shakespeare play.

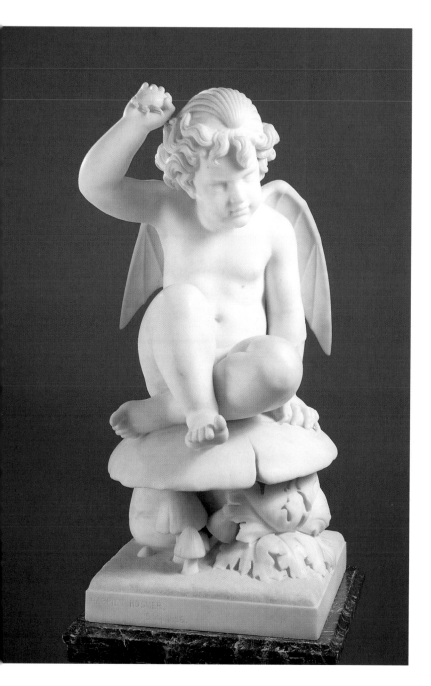

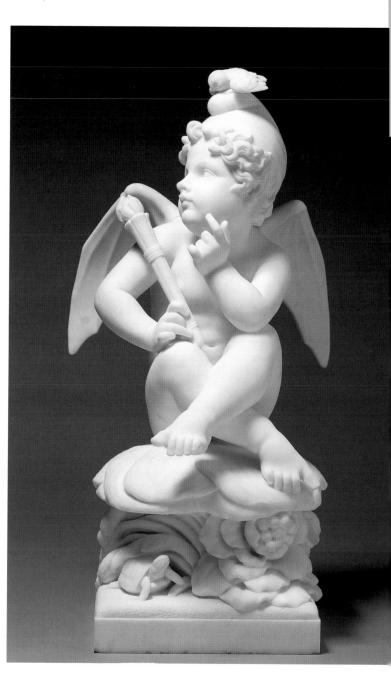

modeled 1854, carved 1856, marble
77.5 x 42.1 x 49.9 cm, Smithsonian American Art
Museum, Gift of Mrs. George Merrill

modeled 1858, marble, 82.5 x 42.5 x 43.2 cm
Smithsonian American Art Museum

THOMAS HIRAM HOTCHKISS

1834–1869

Torre di Schiavi

1865, oil

56.9 x 88.1 cm

Smithsonian American Art Museum

American artists of the late nineteenth century found enchantment in the old ruins and warm light of Italy. They painted scenes like this, which romanticized the countryside and evoked a passion for the splendor of the Roman past. While a goatherd sleeps against a marble frieze in the foreground, a ruined tower dominates the landscape and its reminders of a grand civilization—urns, aqueducts, and decorative capitals. A tiny skull is visible at left. In 1865, the United States itself was emerging from the Civil War. Soon it would contemplate the ruins of its own culture and find a way to restore the spirit of its past.

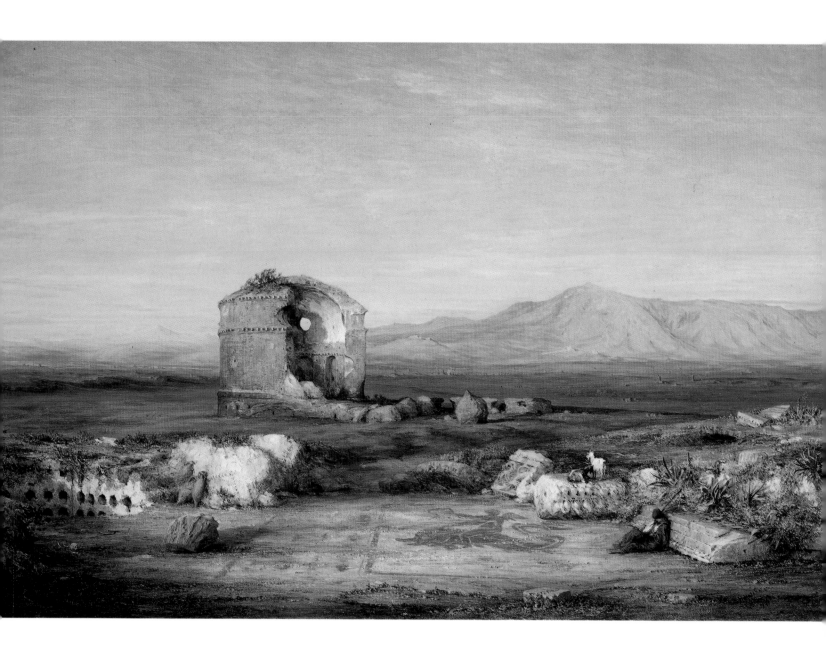

DANIEL HUNTINGTON

1816-1906

Italy

1843, oil
98.1 x 74 cm
Smithsonian
American Art
Museum

As many American artists did, Huntington extended his New York City art training with studies in Rome. An alluring dark woman wielding a paintbrush is Huntington's personification of the Italy he had come to love. Posed before a Tuscan landscape—with a bell tower at right and ancient ruins at left—she documents her country's past glory on canvas as the muse of painting. She evokes the traditions of Raphael, Michelangelo, Leonardo—colossal figures American artists hoped to emulate. It was Huntington's early ambition to introduce to American art the element of allegory, where a physical form stands for an abstract idea. American writer Henry James would have agreed with Huntington's characterization. In his writing he equated the Italian scene with "the idea of beauty, of dignity, of comprehensive grace," and suggested that it is the "fusion of human history and mortal passion with the elements of earth and air, of colour, composition, and form, that constitutes her appeal."

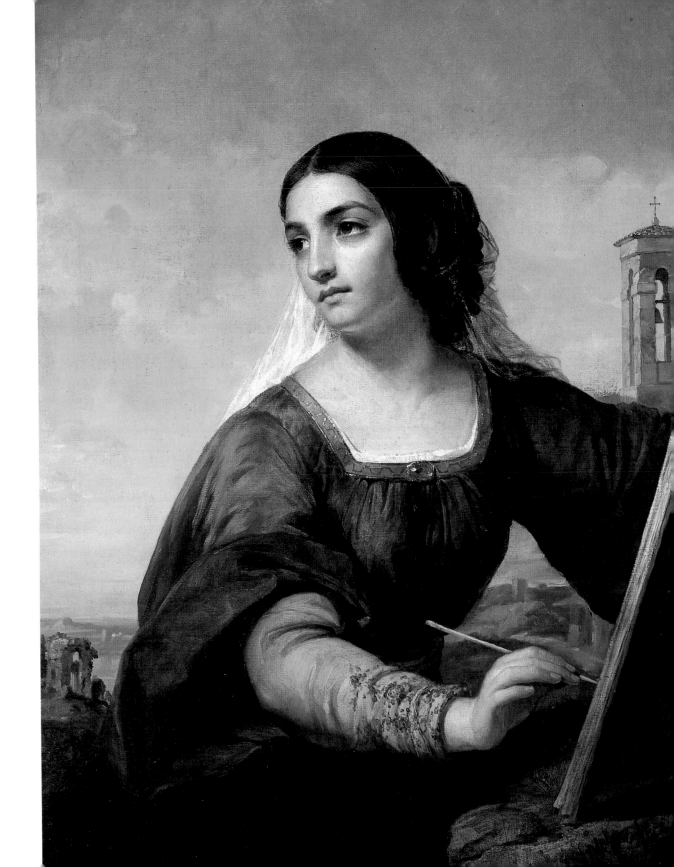

Portrait of Mrs. Barbara Baker Murphy

Portrait of Sea Captain John Murphy

A self-trained artist and former slave who had purchased his freedom, Johnson nevertheless secured commissions from early Maryland's leading white families. These portraits are simple in execution, but also crisp, colorful, and finely detailed. Captain Murphy's gold buttons gleam with the artist's skill, and Mrs. Murphy's delicate cap, lace collar, and fine jewelry are convincingly wrought. Captain Murphy, who lived in Baltimore with his wife and three daughters, probably commissioned Johnson to paint these likenesses as keepsakes or for family records, which was a custom of the time. These portraits were meant to be displayed together. Positioned to slightly face each other, the figures turn to meet our onlooking eyes.

Although other portraits by Johnson survive, little is known about his past. Like many African American artists of his day, he was late in being rediscovered, but it is thought that his successful transition from indentured artisan to portrait painter helped pave the way for others who similarly sought to turn former white masters into patrons.

about 1810, oil, 55.3 x 44.8 cm

Smithsonian American Art Museum

Gift of Sol and Lillian Koffler

about 1810, oil, 54.6 x 44.5 cm

Smithsonian American Art Museum

Gift of Leonard and Paula Granoff

THOMAS LeCLEAR

1818–1882

Interior with Portraits

about 1865, oil
65.7 x 102.9 cm
Smithsonian
American Art
Museum

Two children, a brother and sister, stand frozen before a gray landscape backdrop. They are posing for a studio photograph. The sister supports her younger brother's back with one hand and grasps his arm with the other. He had better not move! It's early in the age of photography, and having one's photograph taken is a long and sometimes tortuous affair. With exposure times often requiring several minutes, the subjects had to remain motionless, a difficult enough task for an adult, let alone a child.

What complicates matters even more for the children is that the photographer's studio contains distracting clutter: photographs and painted portraits peer down at the children from the center wall, a marble bust glances at them from the left, and a dog peeks in from the open door, looking across the room at his master who is hard at work under the dark cloth. Abandoned garments in the two chairs on either side of the children suggest that their parents have stepped away and, like us, are watching from outside the canvas. They—and we—are included in a visual joke, in which the new art of photography and the established tradition of painted portraits vie for prominence.

Museum purchase made possible by the Pauline Edwards Bequest

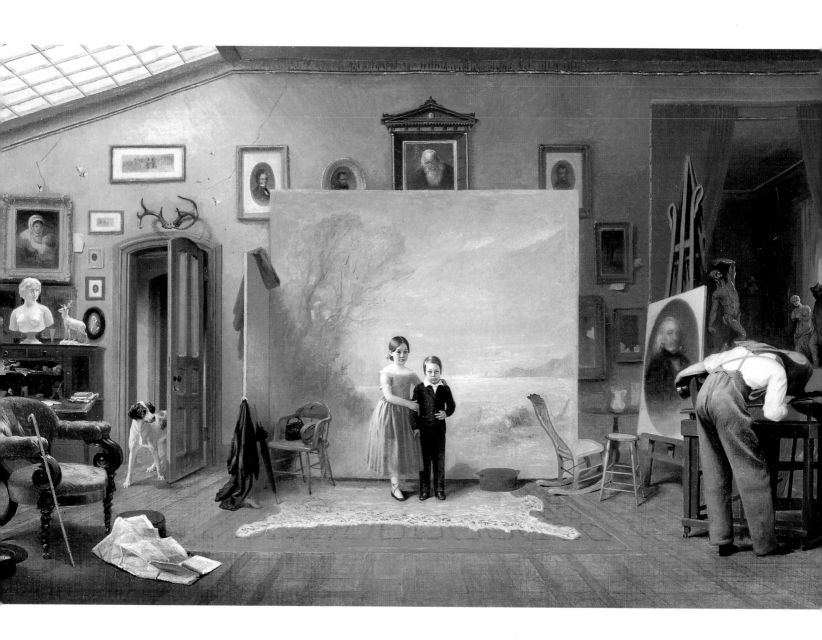

HOMER DODGE MARTIN

1836–1897

The Iron Mine, Port Henry, New York

about 1862, oil
76.5 x 127 cm
Smithsonian
American Art
Museum, Gift of
William T. Evans

The striated rock that rises sharply from the still water forms a steep track, which leads from the ore-filled dock to the mine entrance. Scrubby plants cling to the top of the rock face. They are all that is left of the foliage that once covered the mountain. The tranquil water, cloudy with silt, recalls the violent ravaging of the landscape. The artist has used short strokes of gold, green, beige, and clay-colored paint to depict the layered rock. Black staccato-like dots of paint represent the cascading pieces of ore that have tumbled down to the shoreline from the open mines that seem like wounds on the hillside.

This scene, which records man's forcible contact with the land, is mysteriously devoid of human activity. But the small shack, dock, and barge—seemingly locked in place between the heavy mountain and water below—remind us of the industrial revolution's impact on the environment.

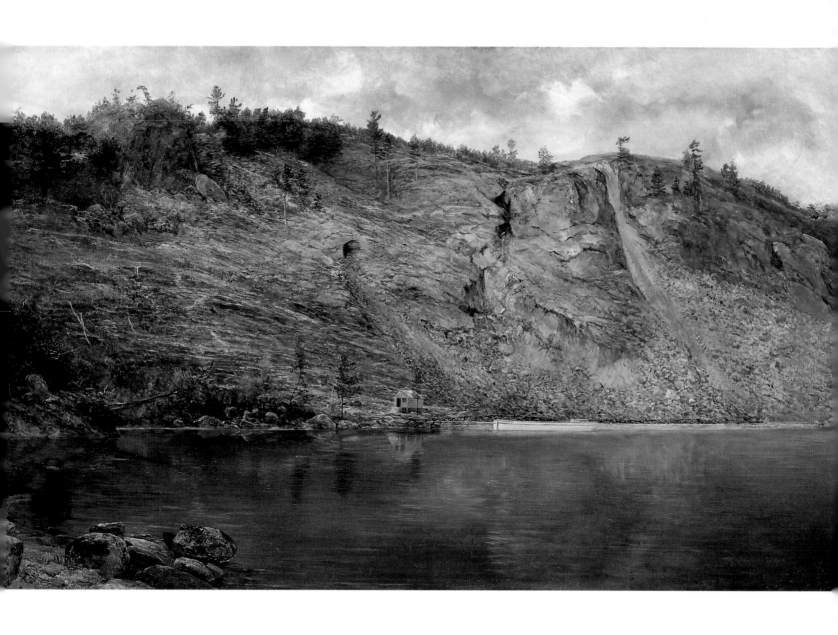

FRANK BLACKWELL MAYER

1827–1899

Independence (Squire Jack Porter)

1858, oil

30.4 x 40.3 cm

Smithsonian

American Art

Museum,

Harriet Lane

Johnston

Collection

Mr. Porter has put down his hat, propped up his feet, and picked up his pipe. He's his own man, a free spirit looking out from the porch of his rustic but comfortable house. His wiry hair stands on end and his clear gaze is focussed on some distant sight beyond the canvas. He looks fit— he could leap off this porch if he chose to. But there is no urgency. Mr. Porter, in his retirement, is the very image of independence.

Mayer depicts his friend—a veteran of the War of 1812—in his golden years, and in fact, gold tones pervade the image in the porch, house, and trees. Mayer himself had inscribed over the door to his house in Annapolis the motto "He lives best who lives well in obscurity." The 1850s were relatively quiet years in the eastern United States, and here Porter, though alert, is blissfully unaware of the approaching havoc that the Civil War and industrialization will bring to American life. One wonders if there is a Mrs. Porter. Perhaps she is the absent owner of the knitting left on the windowsill. If so, she's also taking a break from her work.

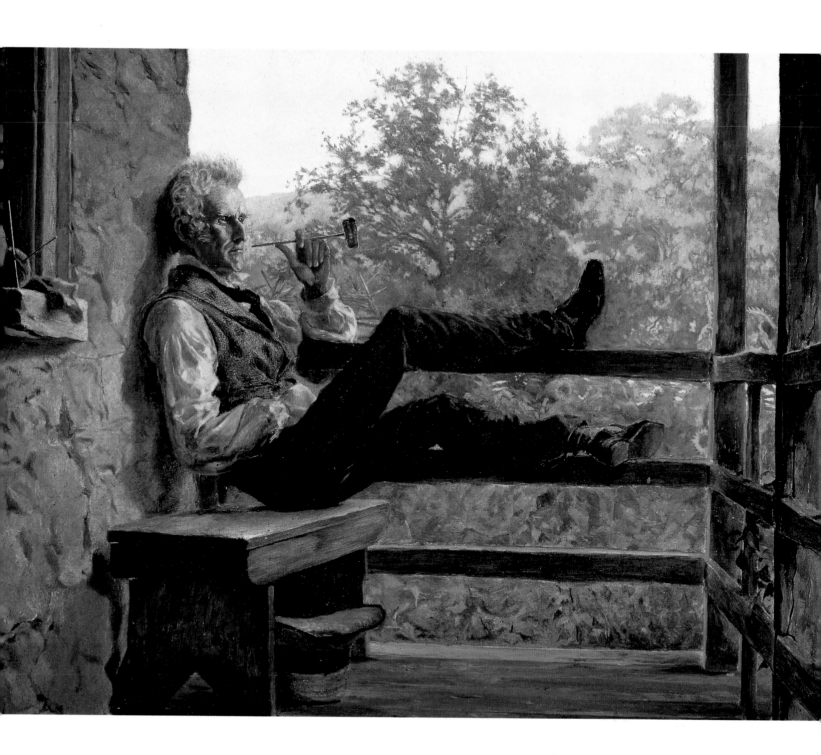

ERASTUS DOW PALMER

1817–1904

June

1865, marble
61.3 x 43 x 26 cm
Smithsonian
American Art
Museum

The marble bust of a young woman, lips parted expectantly, could be a personification of a season or perhaps a muse of one of the arts. Palmer's model, with lovely ringlets and an outward gaze, conveys a warmth, while the pristine marble suggests the unblemished beauty of eternal youth. Though carved in hard stone, she appears convincingly real.

Unlike many of his contemporaries who studied in European academies, Palmer was self-taught, and enjoyed a successful career in Albany, New York. He chose not to depict themes of antiquity in his work. His art dealt instead with American concerns and his style was wholly his own. Such unique execution and emphasis on nature in portraiture made him an all-American sculptor and won him a loyal following. He successfully fulfilled his own stated goal, which was "not to imitate forms alone, but through them to reveal the purest and best of our nature."

Museum purchase in memory of Page Cross through the Director's Discretionary Fund

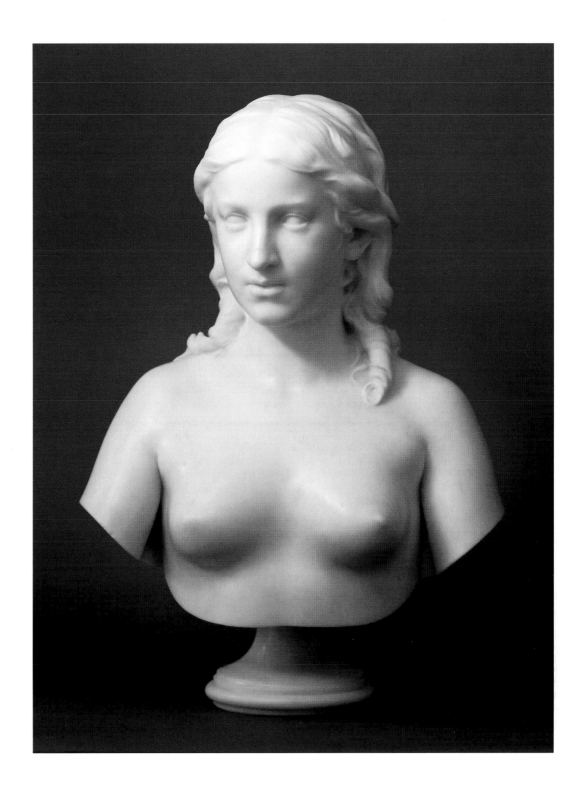

CHARLES WILLSON PEALE

1741–1827

Mrs. James Smith and Grandson

1776, oil

92.4 x 74.3 cm

Smithsonian

American Art

Museum

Every boy should have a grandmother like Mrs. Smith, who clearly adores her grandson in this lovely portrait by Charles Willson Peale. The kindly, affectionate old woman has her arm around the child, pulling him close to her. They cling together against a warm earthy background, their faces bathed in a gold light. Her reflective look suggests that she is meditating, perhaps on his promising future.

The boy looks out at the room with bright eyes that resemble his grandmother's. In his blue coat with large brass buttons, delicately embroidered vest, and frilled collar, he seems like a miniature statesman of the revolutionary era, and indeed he may aspire to that career. He holds a book called *The Art of Speaking* and points specifically to the text of Hamlet's soliloquy, "to be or not to be." What an appropriate question for a boy to ponder in 1776! Maybe he will grow up to fulfill his grandmother's dream of American independence. The hope of one generation for another is beautifully communicated in this endearing image by one of the great portrait painters of the young United States.

Gift of Mr. and Mrs. Wilson Levering Smith Jr. and museum purchase

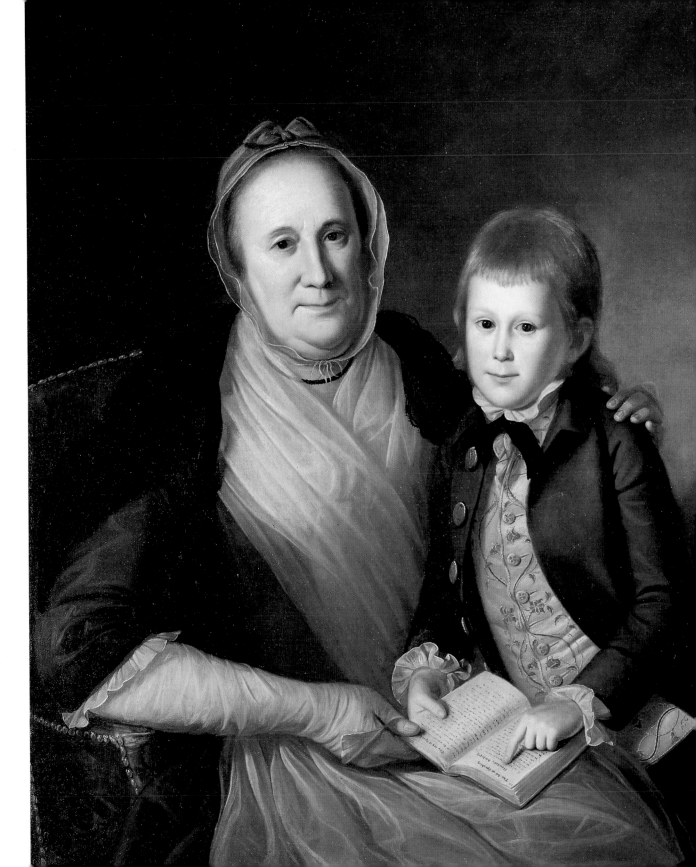

RAPHAELLE PEALE

1774–1825

Melons and Morning Glories

1813, oil

52.6 x 65.4 cm

Smithsonian
American Art
Museum, Gift of
Paul Mellon

Americans were fascinated with the flowers and fruits of their new-found land. Such interest in the natural world stimulated a market for still-life paintings. This type of painting originated in seventeenth- and early-eighteenth-century Holland where merchants demonstrated their wealth through depictions of heavy-laden tables and exuberant floral displays. Raphaelle Peale's famous father—artist and entrepreneur Charles Willson Peale—would have been proud of this effort. The flesh of the melon is so enticing, its seeds and juice oozing out onto the table. The morning glory winds around it seductively. Surely this fruit is too good to eat.

The simple dark background is the perfect foil for the illuminated fruit. This image has a timeless quality, as if the melon and flower will never spoil. Perhaps Peale was expressing the abundance and diversity of the United States of America, which was still a new nation in 1813.

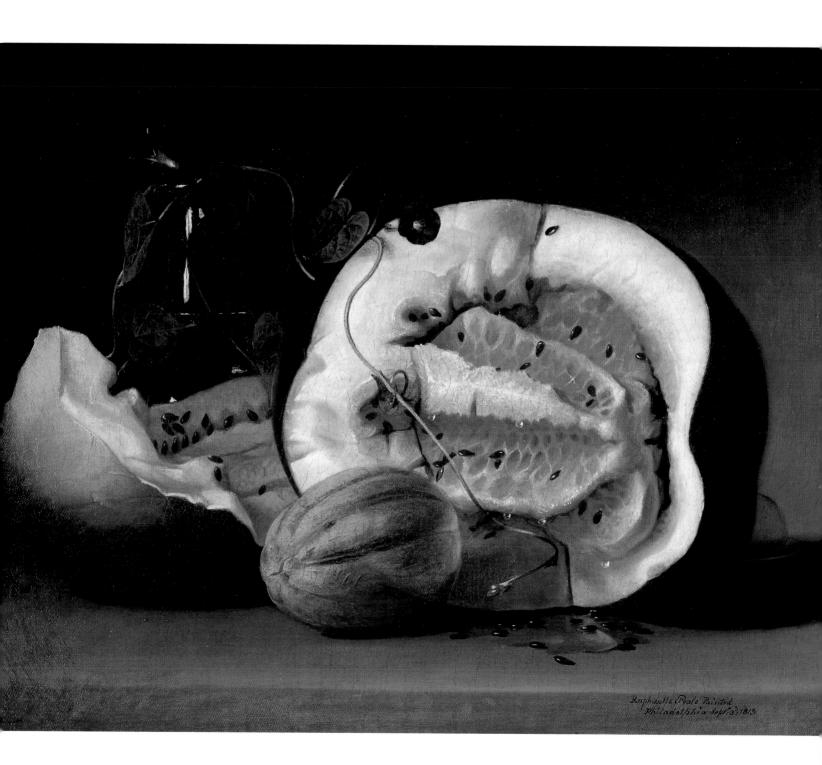

Raphaelle Peale Painted
Philadelphia Sept 3 1813

HIRAM POWERS

1805–1873

Greek Slave

modeled 1841–43
carved about 1873
marble
11.7 x 35.5 x 34.2 cm
Smithsonian
American Art
Museum, Gift of
Mrs. Benjamin
H. Warder

The captive woman turns her head in resignation, resting one of her manacled hands on a draped column, while the other hangs loosely from the irons. Despite her abuse and humiliation, she is the very image of dignity and endurance. The artist has so realistically conveyed her form and plight that the viewer becomes emotionally caught up in her fate. Powers had begun his career modelling figures for a representation of Dante's Inferno in a Cincinnati wax museum, where his ability to render human likeness and sentiment first attracted attention.

This poignant nude refers to the enslavement of Greek Christian maidens by the Turks. However, crafted at a time when the issue of slavery was threatening to dissolve the Union, it also suggests the condition of American slaves, whose will was bound and broken at the auction block. Powers eloquently defended his statue's nakedness against the admonitions of nineteenth-century critics, stating, "It is not her person but her spirit that is exposed."

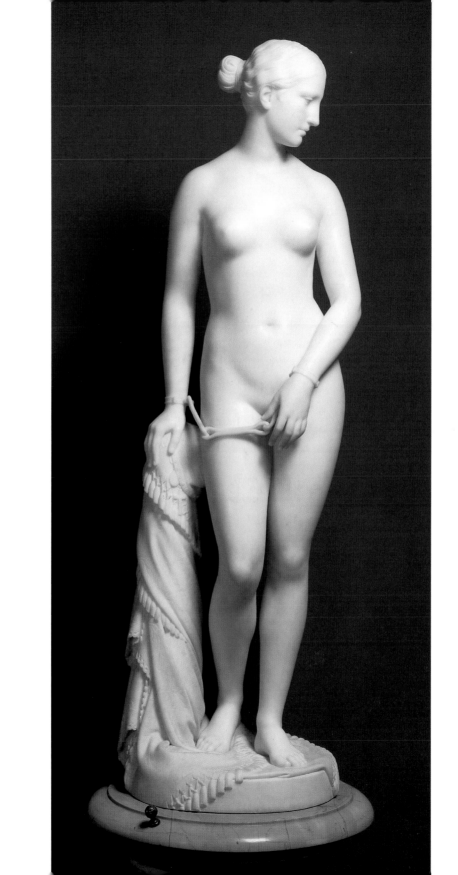

JOHN QUIDOR

1801–1881

The Headless Horseman Pursuing Ichabod Crane

1858, oil
68.3 x 86.1 cm
Smithsonian
American Art
Museum

Looking like a nineteenth-century version of a scene from a Hollywood horror film, this illustration of Washington Irving's famous tale "The Legend of Sleepy Hollow" is hair-raising in its eerie light and shadow. Quidor depicts the moment when Ichabod Crane, flattened in fear on his bolting steed, throws up his hand to fend off the head that the pursuing horseman is about to throw. But it's not a head, just a greenish pumpkin, catching a bit of moonlight. The scene becomes even more sinister when you notice that the twisted tree branches take the form of writhing snakes.

Quidor was well known for his illustrations of Irving's fictional histories about Dutch colonial New York, known then as "New Amsterdam." Irving's stories were favorite subjects among nineteenth-century artists. His colorful characters and improbable yarns created a mythology for an American public that had few literary traditions. This image, which so effectively represents a threat from the unknown, may also convey the feelings of many Dutch descendants in the 1850s, when their traditions were overwhelmed by the burgeoning immigrant population of metropolitan New York.

Museum purchase made possible in part by the Catherine Walden Myer Endowment, the Julia D. Strong Endowment, and the Director's Discretionary Fund

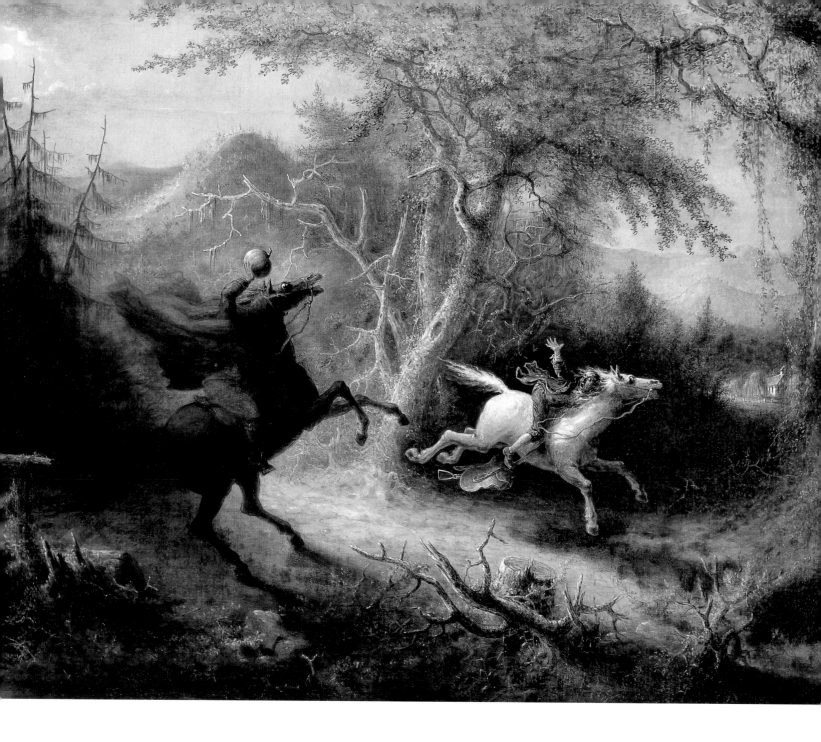

WILLIAM HENRY RINEHART

1825–1874

Sleeping Children

modeled 1859

marble

38.9 x 93.3 x 47.6 cm

Smithsonian American Art Museum, Gift of Mrs. Benjamin H. Warder

Rinehart's exquisite marble statue was so popular in its day that a copy made its way into Queen Victoria's personal collection—and it's no wonder. These two children, not identifiable as either boys or girls, are idyllic cherubs. Their tender white faces glisten, their stone curls fall delicately on their immobile pillow, and their chubby fists grasp each other in perpetual sleep.

A modern mother would run for a camera, hoping to preserve this blissful moment long after her rambunctious pair had awakened. But the average nineteenth-century parent had no such resource and, as in this work, the long-labored monument often served to commemorate the death—and eternal rest—of her beloved offspring. Still, these children are so endearing and lifelike, it seems possible that they will open their eyes and stare up at the viewer, who hovers over their bed like an anxious caregiver instead of a carefree museum-goer.

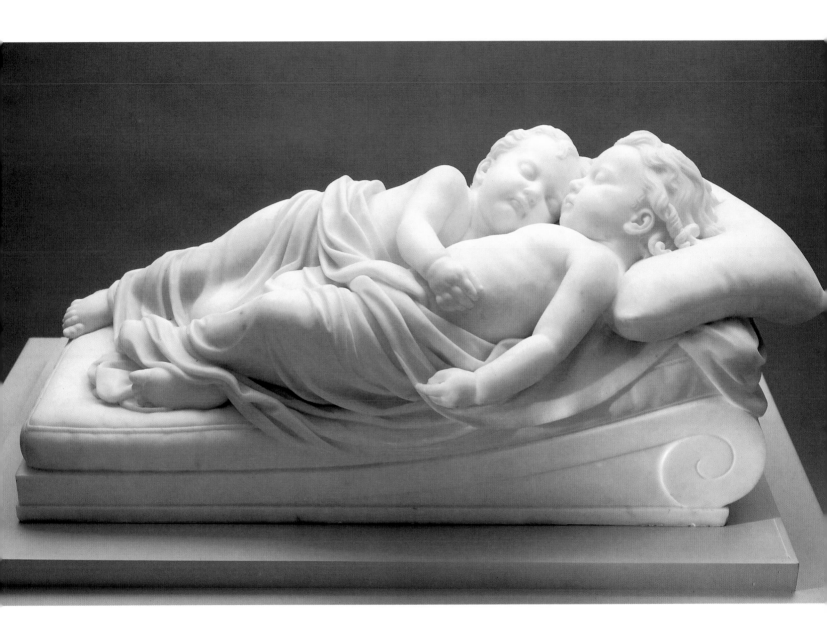

SEVERIN ROESEN

1815–1872

Still Life with Fruit

(detail)
1852, oil
86.5 x 111.5 cm
Smithsonian
American Art
Museum

Today Roesen would be considered a "food stylist" for his calculated arrangements of fruit and foliage. This perfect still life, in which a basket literally overflows with ripe glistening grapes and autumn foliage whose tendrils tie the mass together, is so visually dazzling that you wonder if the food is real. But the light that catches the peeled orange and jagged slice of watermelon hints at human intervention, reminding us that in nature there must always be a flaw.

Roesen, one of many German refugees from the 1848 peasant revolutions in Europe, brought to the United States high standards of craftsmanship. His work was modeled after seventeenth- and early-eighteenth-century Dutch painting. His hyper-real still lifes graced many dining rooms in the homes of collectors who recognized his exceptional skill. These paintings were seen as representing nature's abundance and the sanctity of the New World. Roesen often used the tendrils of grape foliage to form his ornate signature.

Gift of Maria Alice Murphy in memory of her brother Col. Edward J. Murphy Jr. and museum purchase through the Director's Discretionary Fund

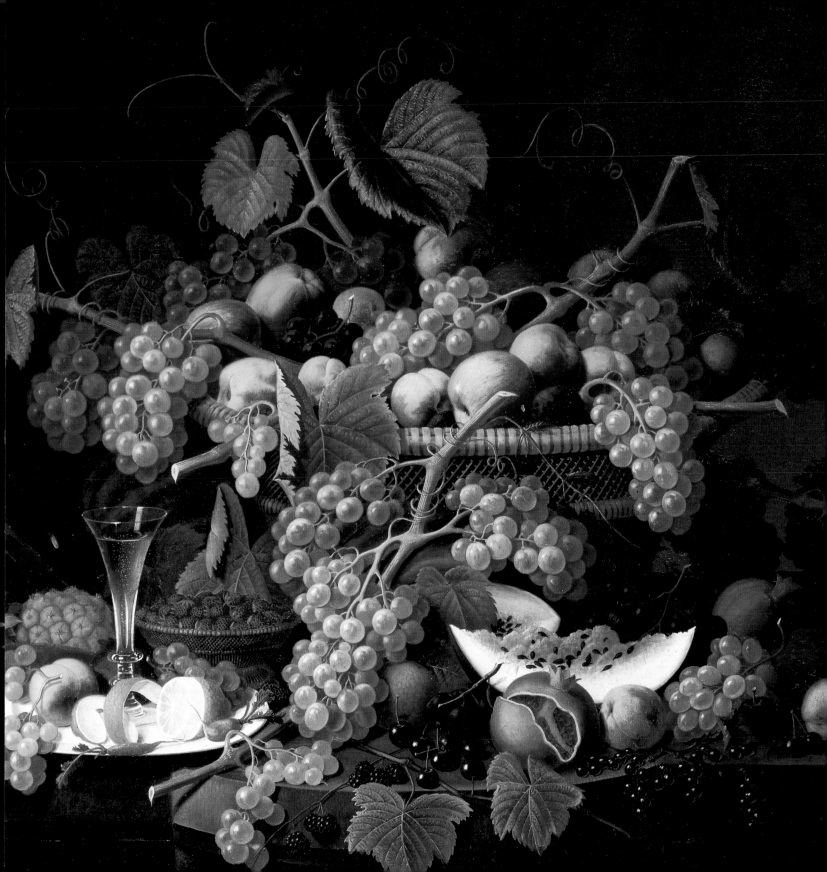

RANDOLPH ROGERS

1825–1892

The Truant

1853, marble
102.9 x 38 x 64.8 cm
Smithsonian
American Art
Museum

A young boy in a hooded cloak steps tentatively onto the ice with a skate. One hand clutches a tree trunk, while the fur-lined boot tests the strength of the surface. Drawn by the glistening ice, he has thrown his books by the side of the tree. He is ready to launch himself onto the frozen pond and forget about school.

This charming truant must have appealed to Rogers's patrons, who certainly remembered similar temptations of their youth. The populace at this time was more forgiving of youthful folly and were more attuned to learning from the "book of nature." As Mark Twain says in *The Adventures of Tom Sawyer*, "The elastic heart of youth cannot be compressed into one constrained shape long at a time." The sculptor's ability to render the various textures of ice, snow, and wood convincingly in polished marble makes this an accomplished work, full of mischief, movement, and bravado.

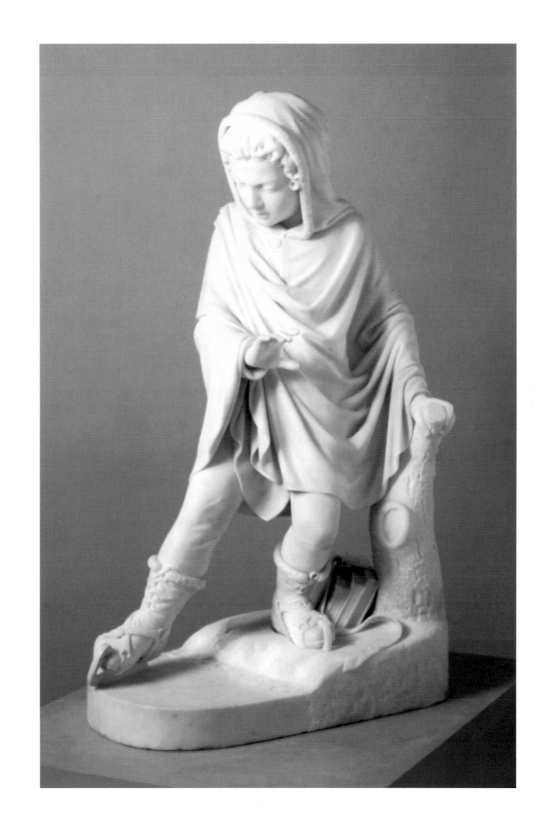

THOMAS PRICHARD ROSSITER

1818–1871

Visit of the Prince of Wales, President Buchanan and Dignitaries to the Tomb of Washington at Mount Vernon, October 1860

1861, oil
69.3 x 138.1 cm
Smithsonian
American Art
Museum,
Harriet Lane
Johnston
Collection

Although there is no patron saint of the United States, if there were it would most likely be George Washington. Even in his own time, our first president was practically worshipped, and by the time this painting was completed, people routinely made pilgrimages to Mount Vernon to see his grave. So the historic visit in 1860 of the Prince of Wales to Washington's tomb was a momentous event, for it signified England's tribute to an American icon, who was once her adversary, and her respectful recognition of the enduring independence of her former colony.

As a history and religious painter by training, Rossiter sensed both the pomp and dignity of the occasion and gave each ample play in his grand canvas. The work both documents the visit and heightens its meaning, through the careful arrangement of figures. At left, we see the Prince of Wales and President Buchanan standing apart from the crowd, their heads inclined reverentially toward the brick arch of Washington's tomb. A cluster of elegantly dressed men and women gather at the other side of the arch, some gazing into it, others at us, connecting the viewer to the event. Dignitaries are also assembled before the obelisks that mark the graves of Washington's family members. They cast reflective looks across the canvas. There is a solemnity and spirituality to the occasion. The single hovering cloud above bears an uncanny resemblance to the profile of the father of our country.

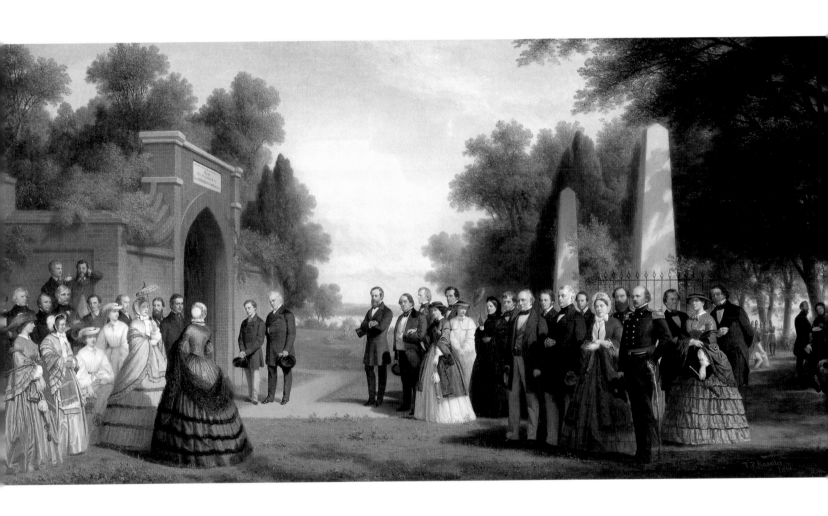

LILLY MARTIN SPENCER

1822–1902

We Both Must Fade (Mrs. Fithian)

1869, oil

182.9 x 136.5 cm

Smithsonian

American Art

Museum

With all her riches and finery, the lovely Mrs. Fithian will be no more able to preserve her beauty than the fragile rose that begins to wither in her grasp. The painting is a sentimental moral of youth and beauty. The extraordinary detail of her dress, a celestial blue satin overdraped with intricately painted lace, the brooch, and waistband that one could touch—they look so real—the petals dropping on the hem and the floor, all highlight the tragedy of time, which, after all, must pass. We, too, are drawn into the drama of this portrait; although we may not possess Mrs. Fithian's wealth, we share her fate.

Lilly Martin Spencer was one of the first professional woman painters in America. She enjoyed great popularity as a painter of children and dogs. Mostly self-taught, she worked for a while in Cincinnati, then the "cultural capital" of the frontier, before moving to New York City.

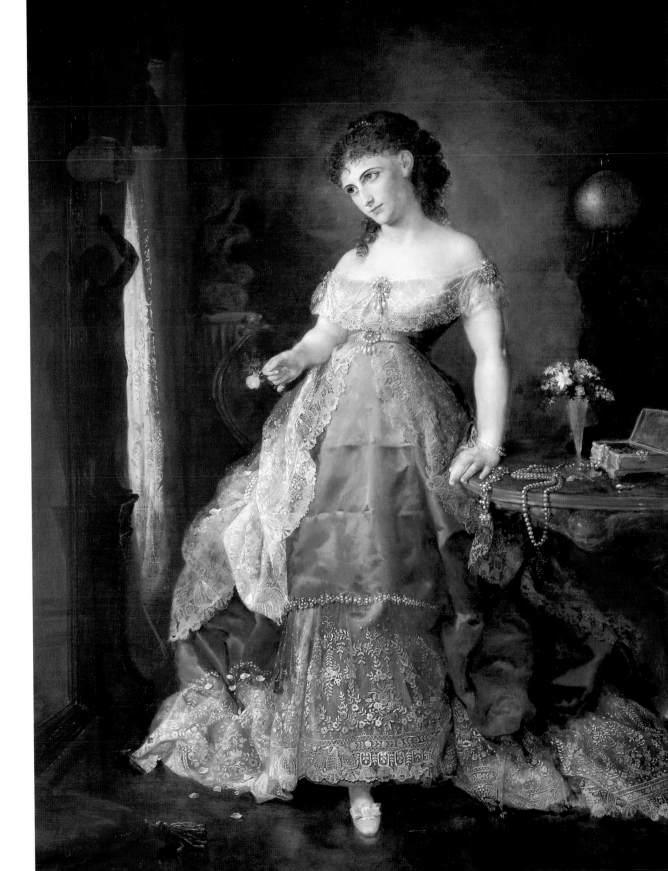

GILBERT STUART

1755–1828

John Adams

1826, oil
76.2 x 63.5 cm
Smithsonian
American Art
Museum

The portly and stubborn second president of the United States, who was revered as a founding father yet reviled by his many political opponents, is depicted in this canvas as a wizened old man. But rather than surrender to old age or sink unnoticed into the comfortable red upholstery of his grand sofa, he holds his head erect and gazes fixedly with rheumy but determined eyes. Always aware of the legacy he would leave to future generations, Adams, in this his final portrait, seems intent on making a lasting impression. His tight lips, set chin, bright eyes, and wild wisps of hair, which create a shaggy halo around his illuminated bald patch, suggest that he is watching our progress as a nation to make sure we live up to the mandate of the generation of 1776.

Gilbert Stuart—the same artist who painted well-known portraits of presidents Washington and Jefferson—must have felt some affection for the crotchety yet brilliant statesman from Quincy, Massachusetts. His spirited brush strokes suggest that there is undying energy and vitality in his aged subject. He left Adams's hand, which is grasping the handle of his cane, unfinished. With his hand somewhat blurred and indistinct, one can imagine that the sage of Quincy is gesturing farewell.

Adams-Clement Collection, Gift of Mary Louisa Adams Clement in memory of her mother, Louisa Catherine Adams Clement

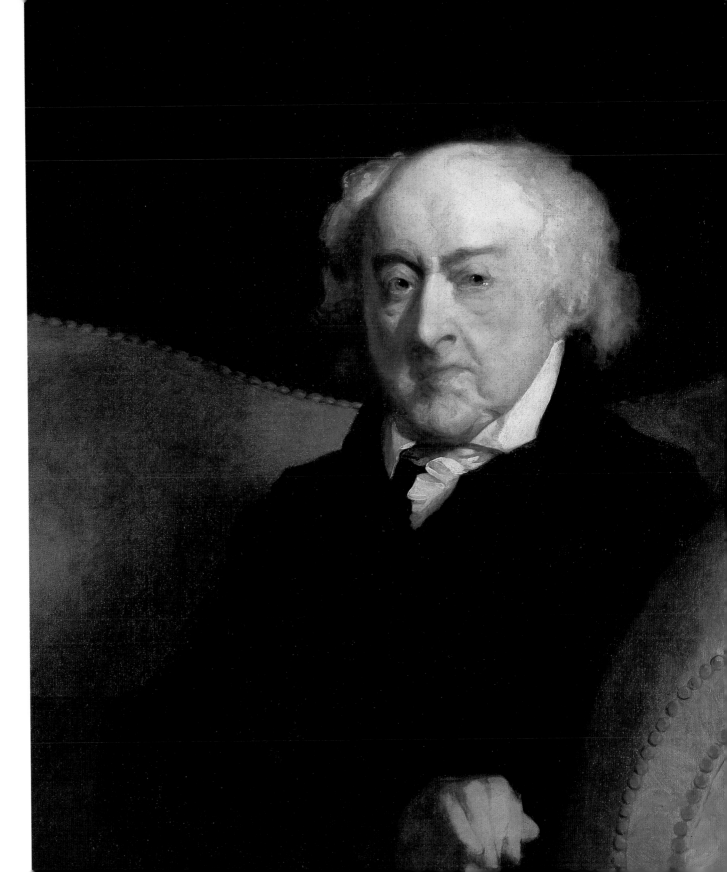

THOMAS SULLY

1783–1872

Daniel La Motte

1812/13, oil
92.3 x 73.8 cm
Smithsonian
American Art
Museum, Gift of
Mr. and Mrs.
Ferdinand
La Motte III

How surprising to see Daniel La Motte, a Baltimore merchant, lounging so casually in a romantic work by famed portraitist Sully. The way he has his arm thrown around the back of the chair, his hair somewhat disheveled, marks him as a figure of the Romantic era. Sully's image of La Motte is introspective and contemplative, implying something about the inner man. The sunset lends a melancholy feel to this work, more in keeping with the likeness of a poet. An indication of his status is his clothing, in the style of English fashion leader Beau Brummel, sumptuously detailed with different shades of white for the waistcoat, shirt, and cravat, and a deep green for the coat, suggesting his prosperity. The lush and ample landscape extending behind his firmly planted right hand indicates his holdings on the Eastern Shore of Maryland and presents him as a gentleman landowner, rather than simply as a merchant.

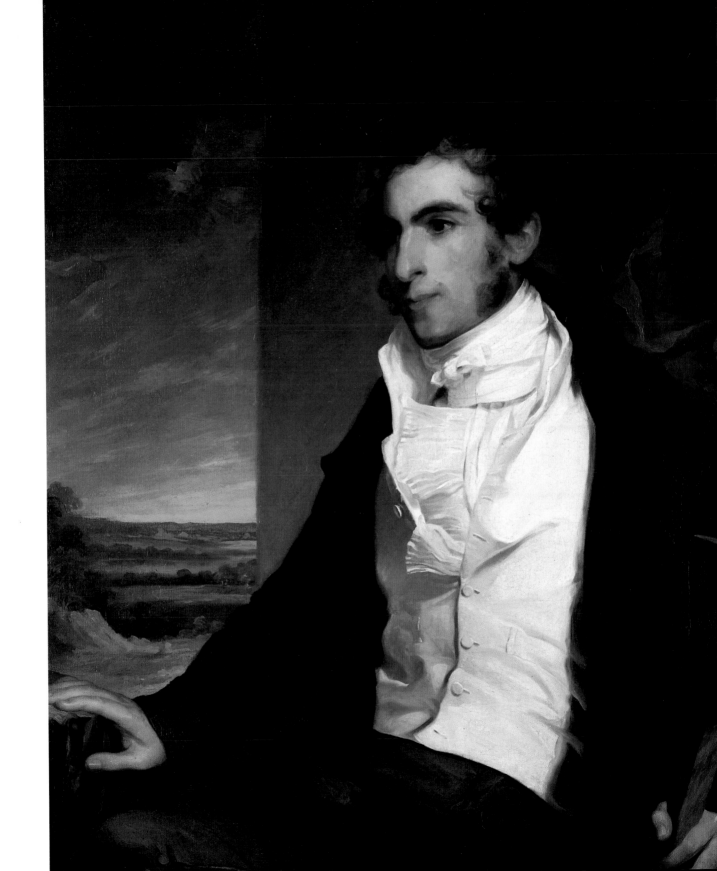

JOHN TRUMBULL

1756–1843

The Misses Mary and Hannah Murray

1806, oil

101.9 x 127.3 cm

Smithsonian

American Art

Museum

The Murray sisters, one engaged with drawing, the other with sheet music, are captivating subjects for this accomplished artist, who was also well known for his service in the Revolutionary War and as a diplomat in Great Britain. In simple white gowns that complement each other—one with a copper-colored bodice, the other with a copper-colored tasseled shawl—they stare out of the confines of the picture's frame, their gazes crossing. The classical column behind them and the dramatic landscape beyond suggest that they are muses within a sacred temple rather than young society women in the well-appointed New York home of their father, a prosperous merchant.

This painting was a departure for Trumbull, who generally painted women as solitary and passive figures against somber backgrounds. Maybe he simply knew these young women better than most of his sitters, or perhaps he made an extra effort to please their father, who was an acquaintance of Trumbull and a founding member of the American Academy of the Fine Arts.

Museum purchase made possible by an anonymous donor and Miss Emily Tuckerman

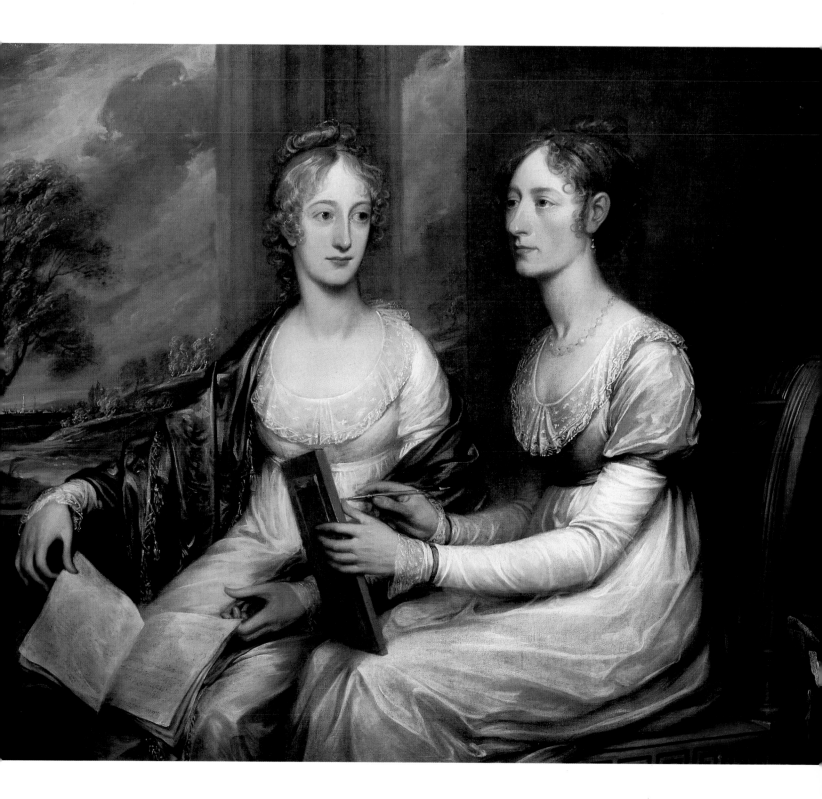

ELIHU VEDDER

1836–1923

Volterra

1860, oil

31.1 x 64.9 cm

Smithsonian American Art Museum

The cliffs of Volterra in the Tuscan region of Italy are so massive here that they actually seem to push the boundaries of this small but panoramic canvas. The rose-hued mountains in the distance provide a sense of depth and space, and the brightening sky, a bit of relief. As one admires the dabs of paint that highlight the sharp fissures in the rock, the brushy foreground dotted with sage-colored trees—probably olive—becomes more apparent, and two miniscule figures at the very bottom of the canvas stride up the hill in the direction of the viewer. Conceived with no more than a few touches of white, red, ochre, and brown paint from the hairs of the tiniest brush, they convincingly make their way toward you, away from the daunting cliffs.

The artist, who was awed by this scene when he visited Volterra in 1860, shares its majesty so convincingly that the viewer feels like a perpetually privileged tourist—able to revisit again and again. At the time, however, Volterra was off the beaten tourist route, the desolate hills harboring dangerous bandits. Vedder never returned, but reused the image of these limestone cliffs in one of his best-known works, *The Lost Mind*, painted in 1864.

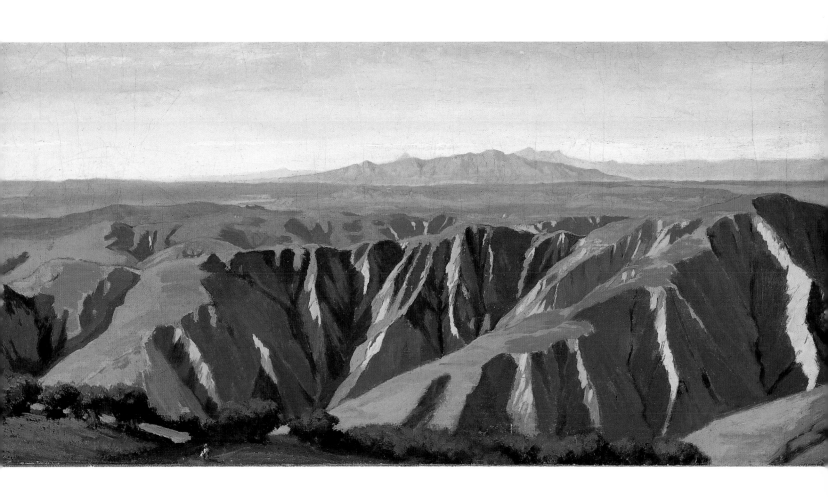

ANDREW W. WARREN

1823–1873

*Long Island
Homestead,
Study from
Nature*

1859, oil
31.6 x 60.1 cm
Smithsonian
American Art
Museum,
Given in memory
of Mr. and Mrs.
I. A. Lipsig

ROBERT WALTER WEIR

1803–1889

St. Nicholas

about 1837, oil
75.5 x 62.1 cm
Smithsonian
American Art
Museum

A semi-merry, semi-grotesque gnome dressed in clothes we associate with Santa appears to thumb his nose at us as he heads up the chimney. Although his pack is filled with toys for the good children, he seems to be the mischievous St. Nicholas of Clement C. Moore's poem "'Twas the Night before Christmas." He has done some damage while accomplishing his Christmas Eve mission—a clay pipe lies broken on the floor, a half-peeled orange is discarded in front of the fireplace, and a stool is upturned at left. Or perhaps this was the scene of a particularly lively Christmas party.

Actually, Robert Weir's popular homage to St. Nicholas, the early Christian bishop who evolved into the American Santa Claus, is filled with references to the Knickerbockers, a cultural group of writers, artists, and patrons who linked themselves with New York's colonial Dutch heritage. Weir was an active member of the group in the early to mid-nineteenth century, when the unchecked growth of New York City threatened to obliterate all traces of its Dutch history. The Delft tiles around the fireplace, the coat of arms with windmill blades above the mantle, and the clay pipes all reinforce Knickerbocker values and remind us that the pleasures of life are fleeting.

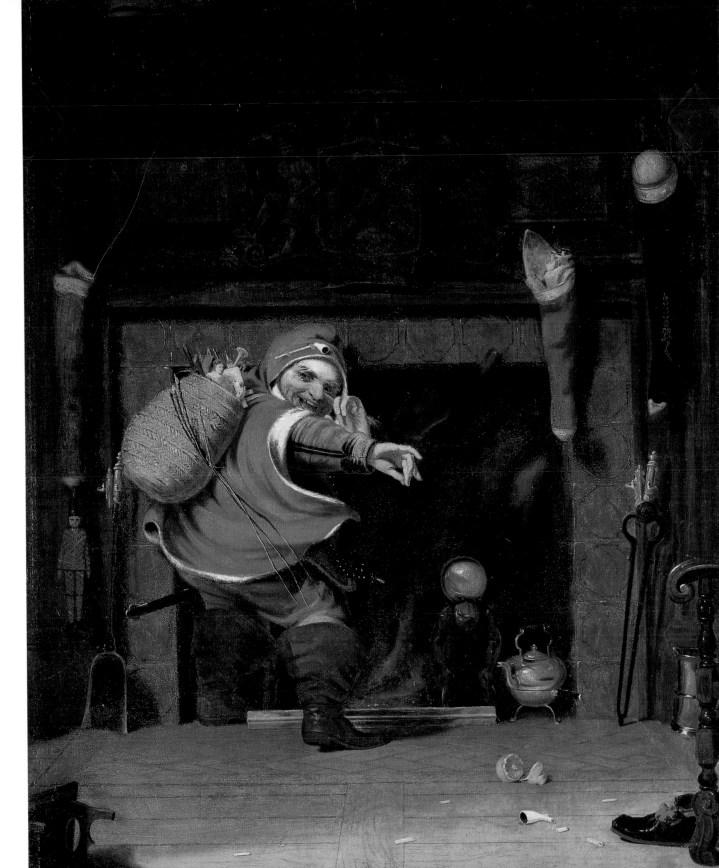

BENJAMIN WEST

1738–1820

Helen Brought to Paris

1776, oil

143.3 x 198.3 cm

Smithsonian American Art Museum

West's beautiful Helen of Troy—the "face that launched a thousand ships"—is awarded to an expectant Paris by Venus and her attendant, Cupid. It is not a happy event. Reluctantly guided by the goddess and pulled forcefully by Cupid, Helen turns her lovely face toward Venus as if to ask "why me?" The painter has selected a moment full of drama and tension. In Homer's epic tale, the abduction of Helen was the spark that ignited the Trojan War. In this canvas West shows his mastery of an imaginary scene, with Cupid's shadowed eyes foretelling the dark events to come. The choice of this narrative from classical literature may also allude to the eruption of violence in America, when Revolutionary troops took up arms against the British in 1776, the year West completed this painting. Though he was both a close personal friend of George III and served as his historical painter, West remained a dedicated proponent of the rebel American forces.

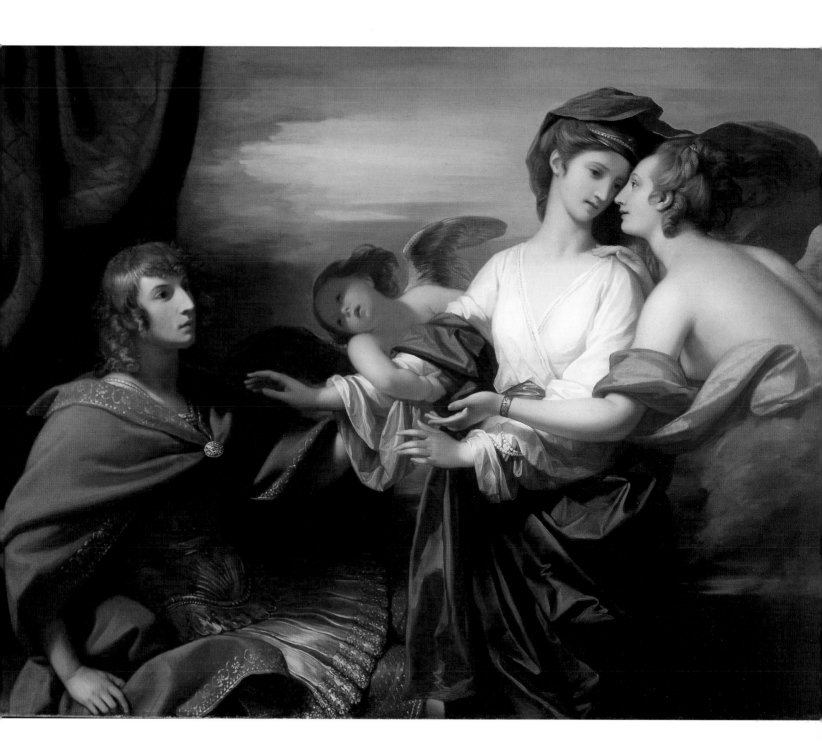

WORTHINGTON WHITTREDGE

1820–1910

The Amphitheatre of Tusculum and Albano Mountains, Rome

1860, oil
61 x 101.6 cm
Smithsonian
American Art
Museum

The quiet ruin of a Roman amphitheater is the setting for this work by Whittredge, who like many American artists of his day trained in Europe during the mid-nineteenth century. His poetic approach to the subject can be seen in the circular pattern of the amphitheater and the undulating curves of the landscape. A goatherd, sleeping on the stone benches of the theater, has let his flock wander in a serpentine line from his hut, shadowed in the middle ground of the painting. A few goats are scattered in a sunken area, once a stage, which is now no more than a few stones and columns. A barely perceptible figure, at left, stands below what must have been the walls of an ancient town. The gentle Albano Mountains dominate the background.

Whittredge's ardent love of the landscape must have temporarily confused him when he came to name this work. This theater is not the one that existed at Tusculum, but a smaller one in the nearby hills. Yet there is no mistaking the artist's intention to forge a link between the ancient past and the pastoral present. During the nineteenth century, Italy was in political upheaval and a common theme among painters and writers was its decline from the glories of ancient Rome.

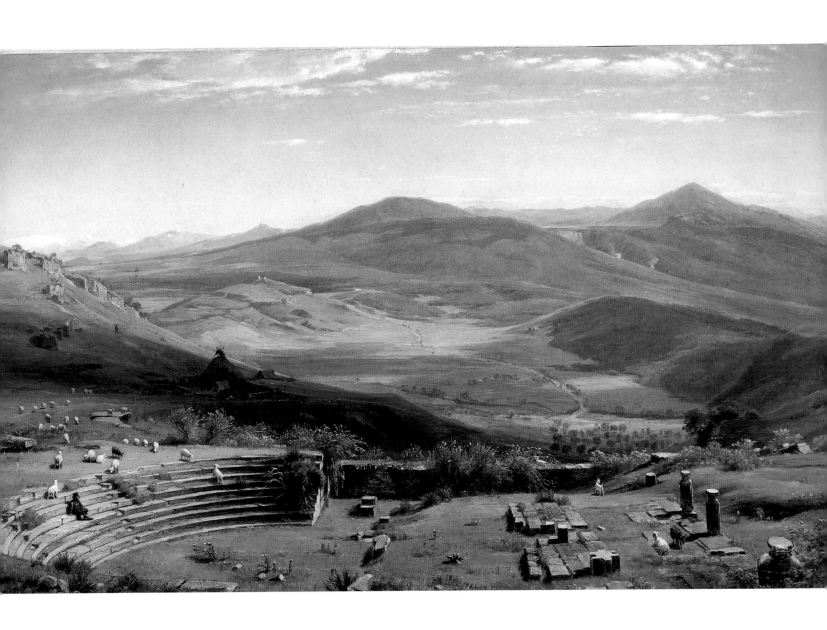

Index of Titles

The Smithsonian American Art Museum is dedicated to the preservation, exhibition, and study of the visual arts in America. The museum, whose publications program also includes the scholarly journal *American Art*, has extensive research resources: the databases of the Inventories of American Painting and Sculpture, several image archives, and a variety of fellowships for scholars. The Renwick Gallery, one of the nation's premier craft museums, is part of the Smithsonian American Art Museum. For more information or catalogue of publications, write: Office of Print and Electronic Publications, Smithsonian American Art Museum, Washington, D.C. 20560-0230.

The museum is also on the Internet at **AmericanArt.si.edu.**